MaiNtENaNt 10(0)

A JOURNAL OF CONTEMPORARY DADA WRITING & ART

PETER CARLAFTES & KAT GEORGES

EDITORS

THREE
ROOMS
PRESS

NEW YORK

LONDON I BRUSSELS I PARIS I BERLIN I ROME I ZURICH

SAN FRANCISCO I LOS ANGELES I BASTIA I HIROSHIMA

WWW.THREEROOMSPRESS.COM

MAINTENANT: A JOURNAL OF CONTEMPORARY DADA WRITING & ART
ISSUE 10(0)

Editors
Peter Carlaftes & Kat Georges

Contemporary Adviser
Roger Conover

Design & Production
KG Design International

Inspiration
Arthur Cravan

ON THE COVER:

ARMISTICE
PAWEŁ KUCZYŃSKI

Ink and Digital Illustration

Special for Maintenant: A Journal of Contemporary Dada Writing & Art, Issue 10(0)

©2016 Paweł Kuczyński | Police, Poland

http://pawelkuczynski.com

About the artist: Paweł Kuczyński is a Polish born political art satirist who is anti-war.
He draws and paints. Born in 1976 in Szczecin, he graduated from Fine Arts Academy in Poznan
with a specialization in graphics. Since 2004 he has been awarded more than 100 prizes
and honors, including, in 2005, the "Eryk" prize from Association of Polish Cartoonists.

ISBN: 978-1-941110-44-7 ISSN 2333-2034

Thanks to all the contributors who have made this journal possible again this year, and thanks to all of
the readers, whose feedback continues to be encouraging. Special thanks to Constance Renfrow and
Megan Zimlich for their fine editorial assistance.

MAINTENANT: A JOURNAL OF CONTEMPORARY DADA WRITING & ART
is published annually by Three Rooms Press, New York, NY
For submission details, visit www.threeroomspress.com

Distributed by PGW/Persus (www.pgw.com)

INTRODUCTION:
WARM/HUNGER

As the Doomsayers scientifically predict our Earth uninhabitable
by the next century, we must celebrate NOW. Maintenant.
And reflect upon the end of times our Dada parentage
faced with the onslaught of WW I.

100 years.

Peace is nonexistent. There are no elements to sustain it.
The Warmonger prevails.

100 years.

Humankind increasingly is able to dissipate
the need for intellectual sustenance. Perhaps the same
will hold true in the next century for nutritional sustenance.

As Hugo Ball once said,
"Dada was not a school of artists, but an alarm signal
against declining values, routine and speculations, a desperate
appeal, on behalf of all forms of art, for a creative basis
on which to build a new and universal consciousness of art."

For ten years, Three Rooms Press has actively sought out the
work of contemporary Dada artists from around the world.
For one hundred years, Dada—the alarm signal—has continued.

Happy 10(0) Anniversary.

Maintenant and Dada.

"I hereby

declare that on

February 8th, 1916,

Tristan Tzara

discovered the word

DADA."

—Jean (Hans) Arp

CONTENTS

CONTENTS

CONTENTS

MaiNtENaNt[10(0)]

WARM / HUNGER

Portrait print

MONA JEAN CEDAR

LOS ANGELES, CALIFORNIA

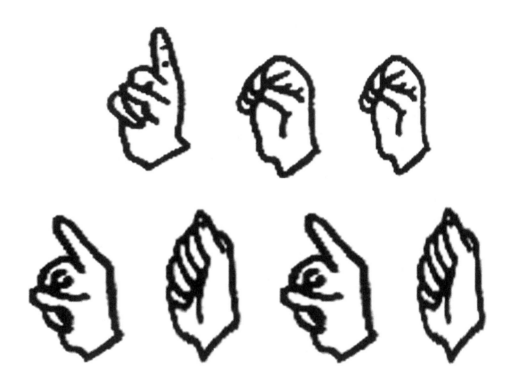

100 YEARS CENTENNIAL OF DADA

Sign Language

MEAL

Ink on paper

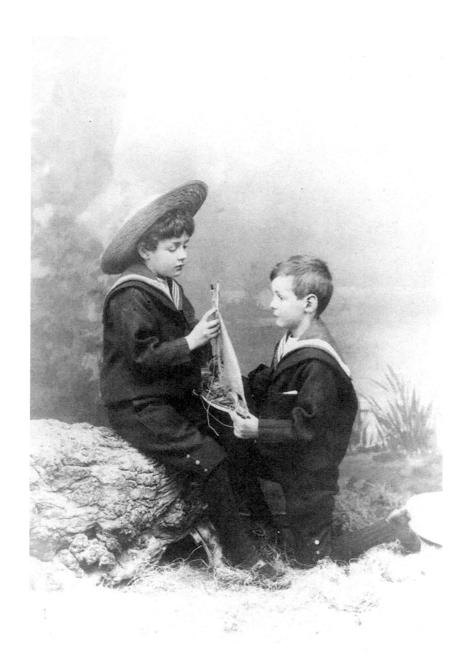

ARTHUR CRAVAN

*Fabian Lloyd (r) examining a model sailboat with his brother,
Otho Lloyd (r). Lausanne, Switzerland, 1895.*

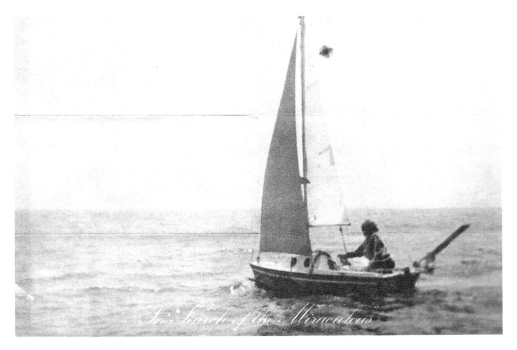

BAS JAN ADER

Bas Jan Ader aboard his pocket cruiser, Ocean Wave. Cape Cod, 1975.

"Glory is a scandal.
Let me state once & for all:
I do not wish to be civilized."
— Arthur Cravan

(from *4 Dada Suicides: Selected Texts of Arthur Cravan,
Jacques Rigaut, Julien Torma, and Jacques Vaché*)

BIBIANA PADILLA MALTOS

WESTMINSTER, CALIFORNIA

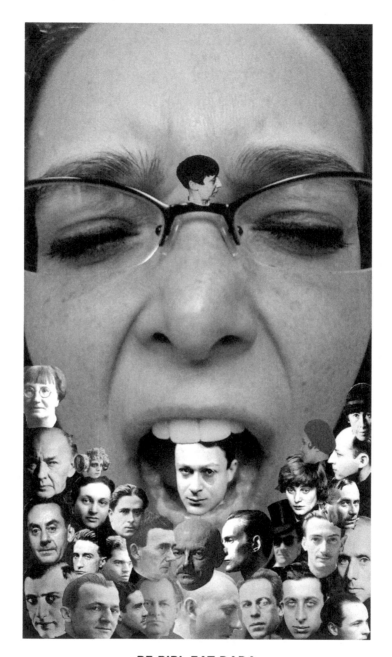

BE BIBI, EAT DADA

digital collage

*T*_{ri}*liazda* StaN
evich TzaRA was a communist
& Da & Da
 meant Yes & Yes
to the Bolshevik Revolution
and not some dumbass
French hobbyhorse
of an artsy vanguardsy

THUS
SPEAKS
NUKELASSYASHA

MATHIAS JANSSON
ÅKARP, SWEDEN

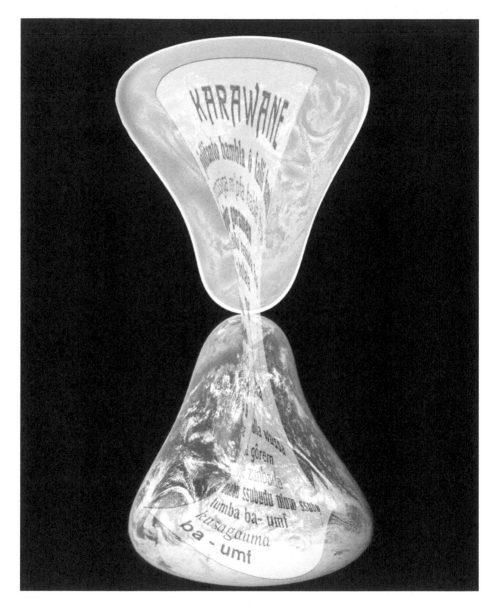

THE COUNTDOWN FOR KARAWANE

Digital illustration

JANAKI RANPURA and ANDREI CODRESCU

MINNESOTA AND NEW YORK

A WAR OF TOILETS IN PEACE TIME

An exchange between Janaki Ranpura and Andrei Codrescu on collaborating on an event for the Dada Centenary in San Francisco, as part of the City Lights' spew of Dada spectacles in San Francisco in November 2016 (www.dadaworldfair.net), organized by Peter Maravelis. I chose this epistolary polemic to illustrate my attempts to defeat Janaki's perfect idea with personal scruples. . . . —AC

Janaki to Andrei

. . . What has been on my mind a lot are TOILETS. I am keenly interested in a bit of info dropped to me by NYC filmmaker Shelly Silver who did a film clip on the Baroness: that there is disputed attribution of the urinal. And that the Baroness used to call Duchamp "Mars," —m'arse . . . I was thinking about a bathroom rigged for auto-triggered toilet symphonies á la Hooter (1923 in Azerbaijan), though this version would be better called Tooter or Pooter ...

I can see building a fighting toilet that roves around the boxing rings. Given time and resources, maybe two fighting toilets, one for Duchamp and one for the Baroness. I imagine them squirting water jets and possibly evacuating themselves at inconvenient times and making great belches of flushing, and having other Japanese-inspired devilries. Let me know your thoughts . . . —*Janaki*

And timely: http://www.japantimes.co.jp/events/2015/07/21/installation-art-guide/oita-toilennale-2015/#.Vo8CCa88KrU

Andrei to Janaki

Hi Janaki: . . . Your toilet symphony is the only kind of humor that makes me actually grit my teeth. This might be my problem. I invented "The Bowel Movement" and had a number of compadres read manifestoes and poetry with me for the occasion, at Intersection Church in San Francisco in 1974 or 1975. The underwhelming reaction still rattles. And we had a cool poster. In retrospect, it was awkward if not retro-silly.

I read that the Baroness shipped Duchamp the urinal from NY to Philadelphia, but it might be hearsay, given the cost. She was mostly broke. Still, they made the point: art is shit and urinals (or toilets) are beautiful. No doubt that art drowned right there and then, but you can also say that it started again in that urino-toilet, like those sea-bugs that come out on land to start people again. And Tzara "shitting . . . on all the flags" is good anti-war rhetoric. The trouble is (and maybe this is good) that I feel neither as phlegmatico-ironic-aristocratic as Duchamp, nor as angry as Tzara. Again, that's my zeitgeist: I can see the point of the boxing match, which is the pointless ideological split now in U.S. and Europe. . . . Toilets remain outside all that and are intrinsically interesting to travelers and cities without running water. Toilet-training is also a grave eternal question. As is psychology. But no matter which way you spin Dada, the actual spectacle of roving and fighting toilets and urinals (genitally symbolic, too!), they also say what the Dadas said already: dada is shit, art is shit... so why are we commemorating it? Because we are shits.

Editor's Note: City Lights Booksellers and Publishers will host The Dada World Fair, celebrating the hundredth anniversary of the emergence of Dada, in San Francisco in November 2016. In addition to the collaborative interventions of Andrei Codrescu and Janaki Ranpura—the roots of which are discussed here—Three Rooms Press will host a Dada Séance on November 10. Details at www.dadaworldfair.net.

Again, maybe there is no better visual way to commemorate, without being either literal (one hundred clowns shitting and pissing on a chessboard made from toilets and urinals) or, au contraire, a re-enactment of WW1, with soldiers literally shitting their pants as artists with easels and berets . . . illustrate the battle from hilltops. God, why is art so boring in commemorative mode? . . . That said the "water symphony" of flushing toilets sounds good. —Andrei

Janaki to Andrei

What is Dada now? I am thinking about it again. Probably mock-terrorism. That is the phony / serious aggression that is turning societal values upside down right now, hmm?

I want to know more about your teeth gritting. I only know that you grit them, not why, precisely, toilet humor makes you do so. There is a whole opus in public toilets. I think they are related to how we as a society consider the public; the public toilet is, to me, a locus of respect and disrespect for that which we have in common, literally sited at the location of a public amenity that is so often withheld or barred from public use. Or, often designed so poorly that it becomes a punishment to pee.

This is less apparent to men, perhaps, who both can pee on the side of a car standing up and nearly never have to wait in a line to pee in a public place. So, the conversation between the Baronness and Duchamp is fired, for me, by ire at the sad sad state of recognizing the restroom as a public good whose design has been so neglected that the restroom comes across as a statement of disdain for the public. Change to: "disdain for the public, possibly misogynistic."

The other part is dealing with the technologizing of the toilet. How a toilet now flushes at you instead of for you. Again, it feels like a paternalistic message to the public, delivered at the crotch (again, a problem just for women, the incessantly inconveniently timed flushes that spray the fanny in a very unpleasant and unexpected way??). . . .

And finally, cultural difference with toilets is very apparent to me. Why do we have the monolith of the great white bowl? There are so many other ways to do it. I will never be cleansed of the sight of a train in India that was delayed by some twenty hrs, everyone unwashed and desperate aboard, confronted with a Western toilet. Most of the Indians didn't know what to do, and the floor was awash with shit. . . . Yes, Dada dealt with shit. We have not dealt with all our shit yet today, though. I don't want to do a reprint of an old theme. I want to find the thing that matters now, that is still shocking and communicative. . . .

Andrei to Janaki

It's true, of course, that SHIT—as that beautiful book Roger (Conover) published said—is the river that runs through human history with nary a whisper of it in the public discourse in and on art. It's a much bigger taboo than sex, even anal, and only clear-minded writers like Colette could describe the desirable man as having a "whiff" of it. I admire candor in all matters—it takes courage. The problem is not the art of bowls, design, or even shit, it's the traumatic life-long presence of both toilet-training and the uncleavable symbolism in shit. Shit and its symbolic effluvia are one: there is no shit-symbol split like the body-mind one.

So that's my problem: I don't know how to separate symbolic shit from real shit. I'm blushing. I'm writing to a woman... I'm not only crude, I'm Victorian! How did Tzara do it? Shit in the shtetl must have been strong stuff—going against it would have been even tougher

I can personally donate my students to making things for the fighting toilettes and keep my participation to an occasional grumble. . . . Thinking. . . . slow to load... trying http...

Your dilemmized cordon sanitaire, as per Prince Charles, —A

Janaki to Andrei:
This, that I just read, seems to be elaborating many of the feelings I expressed to you: "Why not seize [the] moment as a chance to level the porcelain playing field?"

This NYT article: http://www.nytimes.com/2015/12/23/opinion/the-year-of-the-toilet.html ?ref=opinion&action=click&pgtype=Homepage&version=Moth-Visible&moduleDetail =inside-nyt-region-4&module=inside-nyt-region®ion=inside-nyt-region&WT.nav =inside-nyt-region&_r=0 . . .

It is possible that there is a manifesto unfurling, meant to be printed on a toilet roll . . .

Andrei to Janaki
Dear Janaki: . . . What strikes me is that the issue is a new wrinkle in two isms, my personal distaste thanks to communism (communal toilets) and an question of justice in ongoing feminism. Once again, I find the personal (humilated by impersonal collectivism) defeated by justice (a matter of collective justice). There is no paradox here, though it sounds paradoxical: what passed for "communism" in Romania when I was a child was just poverty with an ideological alibi. Whereas a frank look at the design of toilets as unfair to women is an issue of material gravity (the female body) addressing the vision of (male) design. Toilet design, in this case, is blythe disregard by male designers for the design of the female body. You can also say that the communal toilets of my childhood were also in blythe disregard of everyone's body, a disregard that has the "big idea" as an alibi. So the guilty party is always Design. That's the issue in the foreground, and your toilets (in motion as dada masks) are therefore correct. The personal is always the political and vice-versa, a dictum that doesn't rust (Nor does dada)

thank you, Andrei Janaki (JOHN-ah-key)

Janaki to Andrei:
Andrei, we have an incredible opportunity. SF DadaFest spans Election Day 2016. Instead of the Kitchen Debate, how about the Toilet Debate? I can work on joystick-controlled toilets that will assume personae of the opposing candidates and debate on a stage (a boxing ring?) prior to the election. I am crossing my fingers that the fight is between a woman and a man. . .

Can we do a transmogrification of electable versions of Duchamp and the Baroness? Or is it more compelling to take the real-life candidates and satirize? . . . Maybe the set is two bathroom stalls in a unisex bathroom. . . . Maybe it is four stalls and then Duchamp and the Baroness can enter, too.

Hey, I very much like the collective injustice of blithe disregard of everyone's body. Because of my approach in general, I am thinking, in fact, about how people's bodies in the space count for something—this should not be a theater of witness. It is something that should cause more squeaming than that, elicit more basic, hors-de-rational urgency . . .

Andrei to Janaki:
. . . Janaki, this is fantastic! A great opportunitiy to do serious + slapstick + philosophy.

Janaki to Andrei:
It goes on and on—the issue of where the homeless can go to evacuate is def at heart of us "not dealing with our shit" as a society. From the article linked here (https://medium.com/the-development-set/no-toilets-for-the-homeless-55b3b073e919)—"'I piss behind trees,' he said. 'But I don't know what women do.'" AND "Pretty Boy, perhaps because of his youth, adopts a more rebellious tack. Rather than trying to hide, he wants people to know he has to take his private business outside. 'I shit in the dog park,' he said defiantly. 'Then I wait to see how people react in the mornings. If they're gonna treat us like dogs...' he trails off."

"Dada remains within the framework of European weaknesses, it's still shit, but from now on we want to shit in different colors so as to adorn the zoo of art with all the flags of all the consulates . . ." — Tristan Tzara

GERARD MALANGA

NEW YORK

OLD EZ

My whole life I've been on trial, a sleepy trial. I've been the name
you don't easily forget, I'm told,
and for this my work has suffered the lack of recognition it deserves.
I've walked the streets in dreams hungering for more.
Each word a morsel, each word a dream for more.
I could add expletives, but what good would that do?
What good capturing my essence would do?
It would be poison to you,
it would be sleep to you,
the long, dark sleep to hound you, curse you.
Your words, in the end, mean nada,
disemboweled of meaning,
hollowed out like the many tree stumps littering the ground.

In the end—yes,
in the end, the voice fades, gutturing.

What is *poésie?*
He knew a thing or two, old Ez, how words can fail,

words can kill.

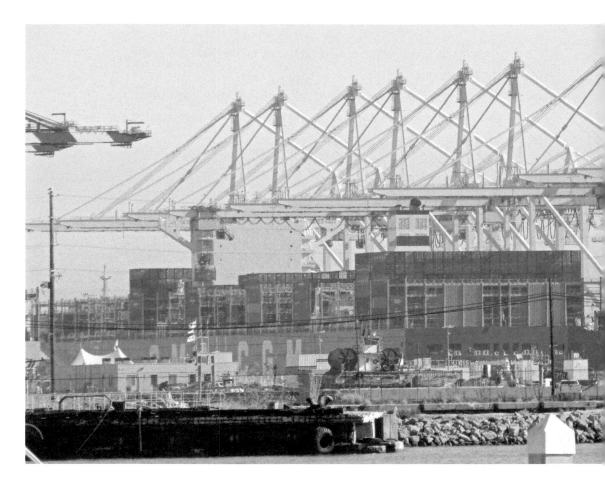

THE BIGGEST CAN BOAT TO EVER DOCK IN NORTH AMERICA

Photograph

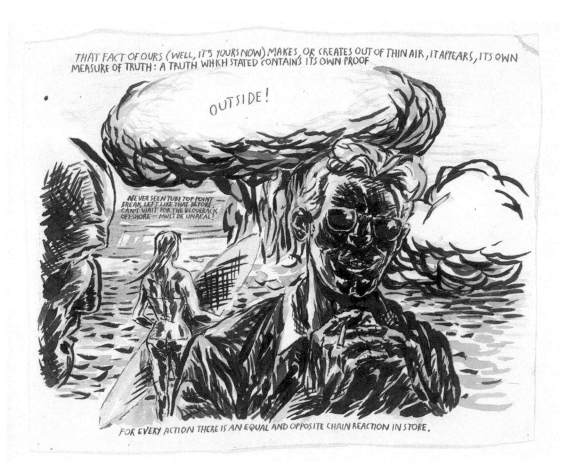

NO TITLE (THAT FACT OF)

Ink on paper; 14-3/5 x 17-3/4 inches

CHARLES PLYMELL

CHERRY VALLEY, NEW YORK

CAT MAN DO

In fact, biology is chaos. Biological systems are the product not of logic but of evolution, an inelegant process. Life does not choose the logically best design to meet a new situation. It adapts what already exists. —John M. Barry – *The Great Influenza*

The morning shows, the grace of strays, the back
streets and alleys of the stars, black mama's boo,
the old days, a different handshake, the dying and
decay, a ray in frightful sunny day, an error in the
equation, a fabric fray, demons in the horns, a lot
of keys, moon full of water, cool rule of the old
school, time to get acquainted with those in
dreams like the blind feeling their way to beauty,
orphans in alleyways, pre dawn call of birds, per-
cussion in the slums, terrible sounds of industry
awake, noise is poverty, potato head viroids base
pairing with other DNA radicals in mountains of
garbage, little crime cells unaware of the loss of
society, governments of infectious diseases, first
in viral sky of superstars and sports heroes for
causes of cancer become the cause itself.

When all the world recognizes beauty as beauty, this in itself is ugliness. — Lao Tzu

Wake up you wanna be artists, poets, impotent
academics to Illuminate the hopeless souls if only
brief as a firefly, dead fish eyes, fools on TV all
looking at me, derivative images, holy hosts of
Hollywood, infestation of bacteria in primordial

slime, cannot shake its presence as if it were an equal piece of the puzzle or lo! The puzzle itself, what distinguishes life from a bacterium in the universe of 99% chance (luck) and 1% intelligence.

LIFE'S THREE DOMAINS
(for politicians only)

The Religion of the Holy Eukaryote: Organisms resembling humans whose cells have a nucleus command and control.

The Religion of the Archaea: An ancient line of microbes without nuclei or suitcases that may make up as much as a third of all life on earth.

The Religion of the New Age Bacteria: The single celled organisms with origins in primordial slime that may or may not possess a nucleus bomb.

CRIMINALS ADAPT . . .
LOGIC IS FOR WAR GAMES & CHESS

Where's the Churchills, where's the Bushes in this archive of agony, shards of life's different branches, an array of pathetic individuals hiding between life and death in the mountains caught and identified by crack detectives. It's rehearsal time for the world where the end is incubating and Jimmy stole your Hyundai.

CLAUDE PÉLIEU

1934 – 2002

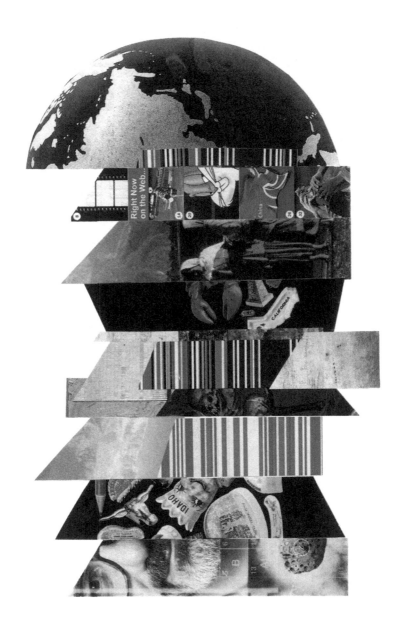

UNTITLED

Collage

MARY BEACH

1919 – 2006

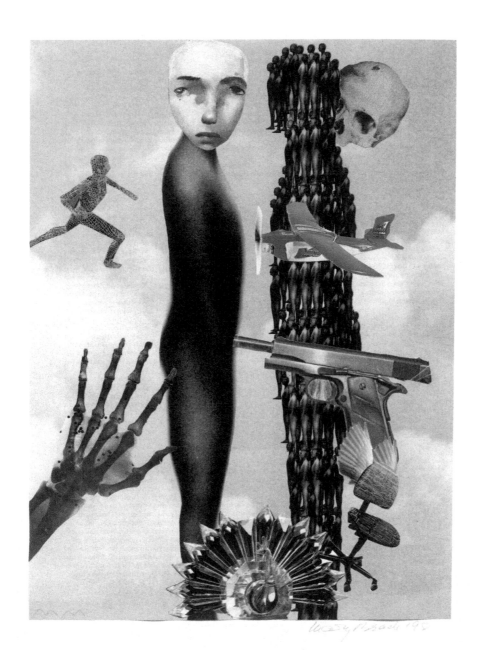

UNTITLED

Collage

DJELLOUL MARBROOK
GERMANTOWN, NEW YORK

MOUSEPRINT

Certain restrictions apply
when you live in an underwater town
hoarding bubbles for air,
sending messages up
in burbles to the splitting light.

Life is low flight over reservoirs
studying street patterns
of drowned towns.
If your erection lasts more than four hours
consider the alternatives—

who knows what they are?
They'll put money in someone's pocket.
Earth is or is not a waterboard, after all,
but an insurance scheme, and death
is a dead-stick landing on water.

"Only a radical cleaning of social and artistic
done by Dada, which is anti-sentimental and

ARMANDO JARAMILLO GARCIA

QUEENS, NEW YORK

NOWADAYS

Here we practice hunger as a fashion

Fur as a protest

There there's no practice or protest

Only the luck of having survived a bomb blast

But don't confuse this for any politics

This is the promotion of ideas

Even as infrastructure is destroyed or crumbles

Water becomes scarce and reporters crawl over themselves

To bring it to you fresh

There's something rotting that inspires our best

Practical bonfires can't help themselves

They paint the night that funnels our thoughts on embers and sparks

To arrive at a tingling cosmic warmth

But the hungry hurl insults no matter how frail

That explode against gun barrels

That then silence them by default

A corpse becoming more real the more it gets mangled

The more it blooms into a cause

life as, in the domain of art, is already
healthy to the core, since it is anti-art."
— Theo van Doesburg

PETER CICCARIELLO

ASHFORD, CONNECTICUT

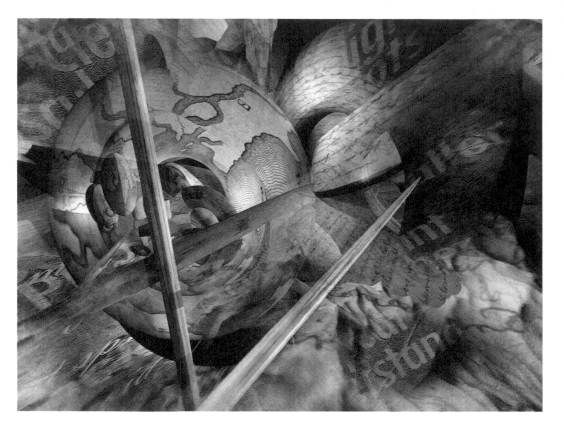

THE BEING OF MAN SLICING THROUGH THE THIN SKIN OF LANGUAGE

Limited edition digital master print;15 x 20 inches

PATRICE LEROCHEREUIL

NEW YORK, NEW YORK and PARIS, FRANCE

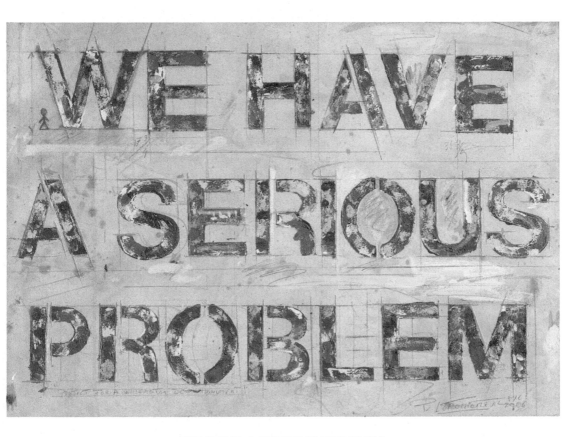

WE HAVE A SERIOUS PROBLEM

Acrylic painting on washed paper. 30 x 22 inches

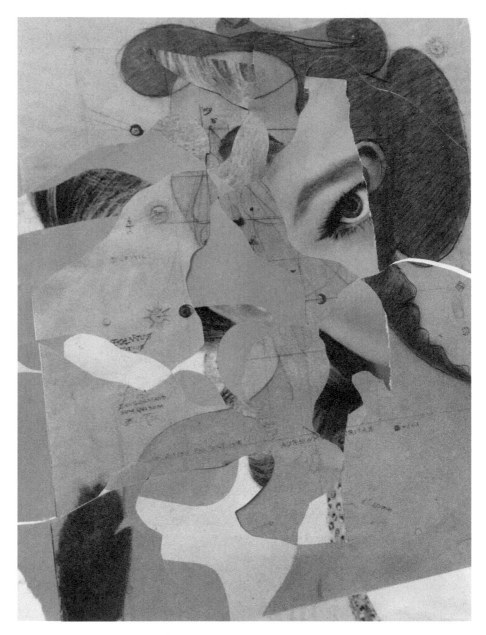

RIDING THE NEW PHANTOM MULLINER PARK WARD

Collage

ALAMGIR HASHMI

ISLAMABAD, PAKISTAN

A GREY BOULDER ROLLED DOWN

A grey boulder rolled down
over me ending the hike to fresh springs.
The sky is a cleft in the range for the day.
Yet, a thin stream bubbles through seasonally

and feeds the village pond
where the sun
warms our daub house.
Hard pressed so

I can't raise my voice
behind the rough hillside,
but the murmur echoes back
from the valley, fields, catacombs of waste.

A week of landslides and rock
falling on rock make it stone deaf;
the waters only foam over it,
change course, flow on

to the span of waiting barley.
A waterwheel is still going round
down the track, and women hurry
to fill their earthen pots,

dunes loping just across the line of sight,
a bucket full of emptiness.
They know how the elements change:
when the bottom falls out there's no measure of dearth,

even as the winter sun comes on
to cancel the cold winds
and the sky stops
pouring.

MALAK MATTAR

GAZA, PALESTINE

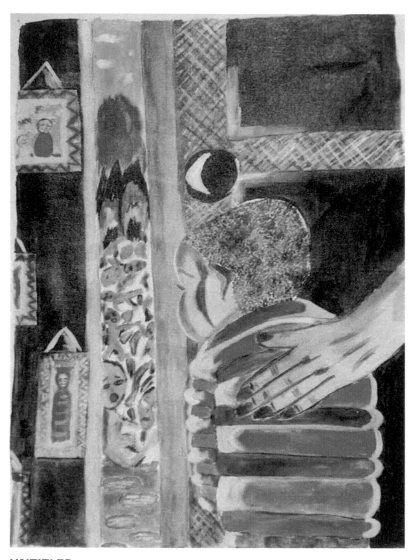

UNTITLED

Painting

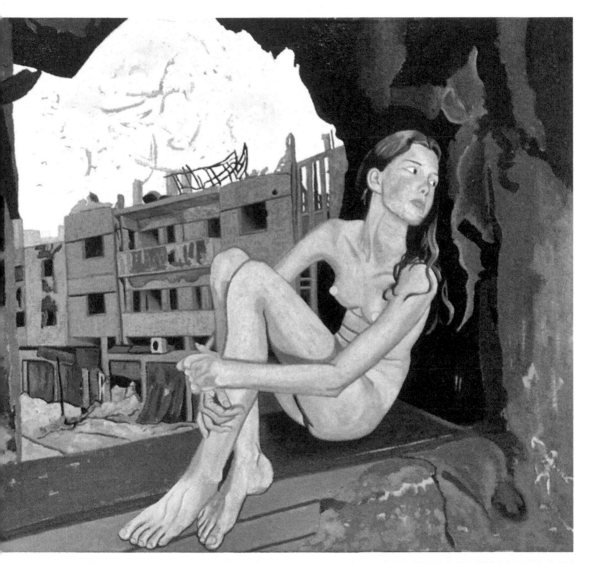

WAITING FOR THE NEXT DAY

Painting

ŽYGIMANTAS KUDIRKA

VILNIUS, LITHUANIA

WRITE A POEM

to burn a tree using a match stick
is the same as to kill a chicken with a boiled egg.

to burn a tree using a match stick
is the same as gerontophagy—
young spiders eat their mother at the end of the brood care period,
they devour their mother with relish;
it seems that this serves as the mother's final act of parental care.

to burn a tree using a match stick
is the same as killing your own father in the city of Kaunas, Šilainiai district,
 Baltic street.

to burn a tree using a match stick
is the same as the mad cow desease—the illness of cattle who were
 industrially fed the bone meal—flour made of other cattle's ground bones.

to burn a tree using a match stick
is the same as ouroboros—a serpent swallowing its own tail.

to burn a tree using a match stick
is the same as to hang yourself with your own tail.

to burn a tree using a match stick
is the same as ritualistic suicide avoiding disgrace.

Seppuku—is a more poetic term that comes from Chinese and it means to
 retire with honor.
Harakiri—is a more vulgar expression, is more like to check out or to kick
 off, to kick the bucket.

Samurai before seppuku used to write a poem, that was a part of the ritual.

So

Before killing a chicken with a boiled egg—write a poem.

Before eating your mother's flesh—write a poem

Before killing your father—write a poem

Before eating flour made out of your own bones—write a poem

Before eating your own tail—write a poem

Before hanging yourself with your own tail—please write a poem

. . .

And all of that—is the same as to burn a tree using a match stick

So, citizen, make a personal effort—prevent forest fires!

Or before setting a forest on fire—write a poem.

"We were seeking an art based on fundamentals, to cure the madness of the age, and find a new order of things that would restore the balance between heaven and hell. We had a dim premonition that power-mad gangsters would one day use art itself as a way of deadening men's minds."
—Jean (Hans) Arp

C. MEHRL BENNETT

COLUMBUS, OHIO

THE PENCIL SONG & NOBODY'S SURPRISE

- admit one light a pencil
- backup admit enter backwards
- admission rate welcome canned words
- discounted rate who said what when why?
- preview films feet in cement shoes
- advance to present global warming
- presentation mode write a song / sing it

Global Warming Song

Pretty pencils, burning in the woods
Pretty pencils, make a forest of words
Each day we sing our warning — "The Earth is warming!"
(warming) (warming) (etc. to fade out . . .)

- fast mode to the future question effectiveness !
- rafting off the roof answer all charges
- please take your seat mam! those in power do not listen
- perform the event, titled: "NoBody's Surprise:

Blow up a balloon until it POPS (this is the Earth)

JOHN M. BENNETT
COLUMBUS, OHIO

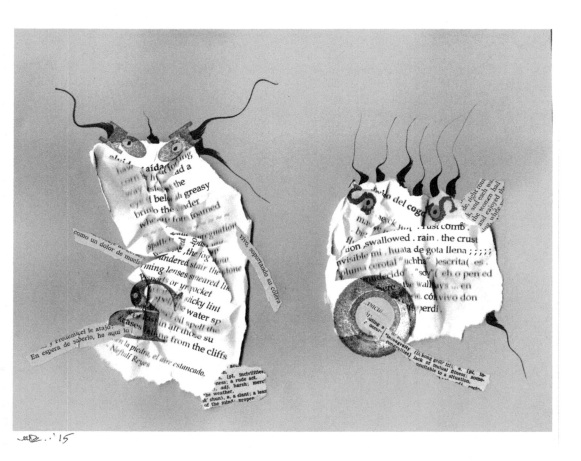

SWALLOWED

Mixed media, letter size

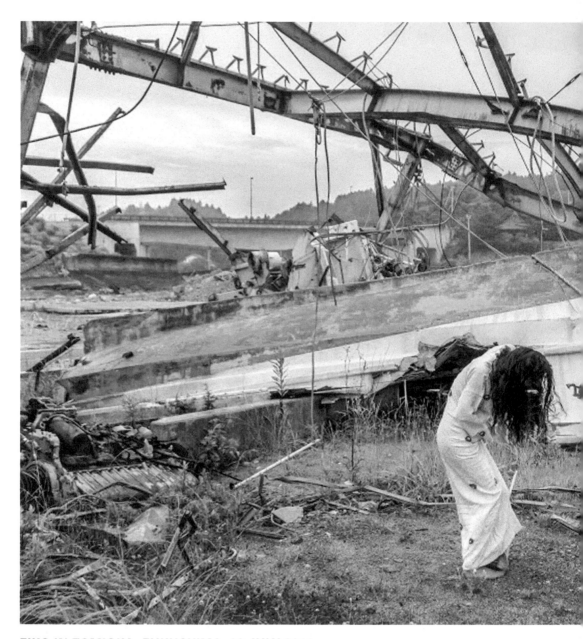

EIKO IN TOMIOKA, FUKUSHIMA, 22 JULY 2014

Photograph by William Johnston

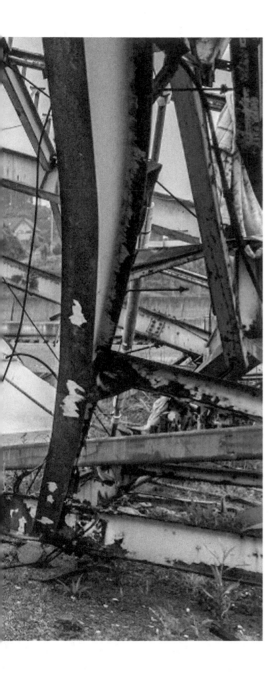

CHOREOGRAPHER'S NOTES:

A Body in Fukushima, a haunting series of photographs, is the collaborative work between Eiko and Japanese historian and photographer William Johnston. Eiko and Johnston have been collaborating for the past eight years as co-teachers of courses in Wesleyan University on the atomic bombings and mountaintop removal mining.

Eiko had conceived the project when Harry Philbrick, the director of Pennsylvania Academy of the Fine Art (PAFA) invited her to perform a 12 hour-durational work at 30th Street Amtrak train station in Philadelphia. To make a strong contrast to this majestic and busy station, Eiko wanted to place her body in very different stations and thought about going to Fukushima. She invited her friend Johnston to collaborate.

In 2014, Eiko and Johnston made two extended visits to the areas surrounding the Fukushima Daiichi nuclear reactors, which were damaged during the massive earthquake and tsunami that hit the northeast Japanese coast in 2011. Only recently have people been allowed to visit these radiation-damaged areas, where access is limited to daylight hours only. The former residents still remain in exile due to the ongoing contamination.

Following the abandoned train lines, Eiko and Johnston visited the empty stations and their neighborhoods, places that formerly bustled with life and people. Over three years since the initial disaster occurred, the buildings hit by the tsunami remain in their damaged state. Those that survived without damage sit in a no-man's land due to the radiation. Vines have grown covering the rusted tracks. In these locations, Eiko embodies bitter grief, anger and remorse, sometimes in vulnerable gestures and at other times dancing fiercely. The photographs by Johnston capture Eiko's evanescent gestures as well as the evolving landscape. As Eiko explains, "By placing my body in these places, I thought of the generations of people who used to live there. Now desolate, only time and wind continue to move."

Johnston regards the project as "a form of witnessing." He writes, "By witnessing events and places, we actually change them and ourselves in ways that may not always be apparent but are important. Through photographing Eiko in these places in Fukushima, we are witnessing not only her and the places themselves, but the people whose lives crossed with those places."

Details: www.eikoandkoma.org/abodyinfukushima

NEELI CHERKOVSKI
SAN FRANCISCO, CALIFORNIA

GIOCOMO LEO

You are hanging upside down
From a tree in my garden
And I can do nothing
But love you anyway

I imagine our planet
As a ripple in time
You are part of that
As you swing back-and-forth

Your name is Leopardi
Celebrant of pretty words
Who built the statue of Dante
To toss against the wind

I love you I love you
Who gave aggressive active verbs for me alone
As I sit on the redwood deck

Giacomo we do not let go
Of the shadow you embrace
Our Journey begins late
We came late true love

We watch you swing
Across the gate warm Italy
Will soon rebuild and a new
Poet Laureate emerge

JEROME ROTHENBERG

ENCINITAS, CALIFORNIA

THREE POEMS FROM
"THE DISASTERS OF WAR" AFTER GOYA

He is a real man
when he murders,
is he not?

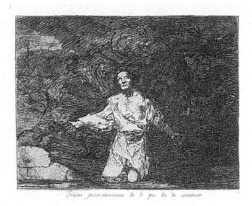

1/
Sad presentiments
of what must come
to pass a rage
of shredded clothes

the darkness
through which images
rain down
a ruined world

of bricks & walls
erased or crumbled
shattered* *splattered
on the broken ground

made present
by an unseen hand
like mine
the lines concealing

men & women
children
trees & gardens
grass gates gravestones

shrines & temples
class rooms
radios & books
old dresses

fifes & fiddles
heirlooms
bicycles
eyeglasses

sidewalks
monuments
engagements
marriages

employees
clocks & watches
street signs
works of art

the man's face
shows it
chest & forearms
swollen

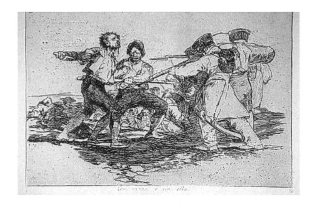

stumps for legs
the cry of blood
so fierce
it stops his heart

his eyes see only
lines like knives
criss-crossing
blood or rain

the word is misery
that binds him* *blinds him
where the waters rush
& rage

2/
with reason
or without
the fate of *real* men
facing off
guns at the quick
or lances

silently
the cries rise up
between clenched lips
the itch & thrill
of suffocation
driving them on

for which the mind
is never still
but races screaming
somewhere beyond
the zone
where real men go

theirs is the dream
of children
& old mothers
huddled masses
at their feet
the dream of where we go

& where the bayonet
enters the sad flesh
the dark device
explodes behind us
ready like them
to make its mark

the blood is like
a ribbon
where it leaves
his mouth
the knife his hand holds
hot to strike

the mind of Goya
falters sightless
writing in a room

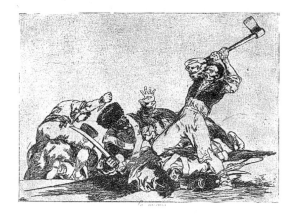

without a light
he feels the thrust
much like his own

the speed of thought
where thought ends
the rest is flights
of spirits
dibbiks who will never
find a home

how heavy
we have all become
trying to free our hands
to etch our names
still mindful that the dead
will never sleep

3/
same thing
from the ax
as from the sword
the fury* *vengeance
of the dead
against the quick

those who survive
remember
knives like lights
cutting through time
& leaving us

minus a hole to hide

swept into death
the boots
the men wear
when the feet
stop moving
stick out of the ground
.
beyond our sight
the earth
will swallow them
no hand upraised
to hold it back
or free us

if my hand
would thrust a knife
like yours
the blow would sever
head from throat
spreading the blood

down mirrors
it will flow
& when they cry
for sunlight
nothing
will answer

but the deadman's
song

AGNETA FALK HIRSCHMAN & ELLY SIMMONS

SAN FRANCISCO, CALIFORNIA

THE PRICE

AGNETA FALK HIRSCHMAN

Such big nostrils on a small child
So much noise from a small mouth
So soft the skin behind the earlobe

A dog on a lead
A man spitting in the street
A bag with an ink stain
A broken paving stone
A veiled woman
A pink carnation

The price of gas
The price of oil
The price of butter
The price of coffee
The price of housing
Thepricethepricethepricethepricetheprice
THE PRICE

Good morning death
Have a nice day

Go to your history lesson
It's live from Baghdad

THE PRICE

Poetry by Agneta Falk Hirschman; Artwork by Elly Simmons
Casein, gouache and collage on canvas; original artwork, 20 x 20 inches

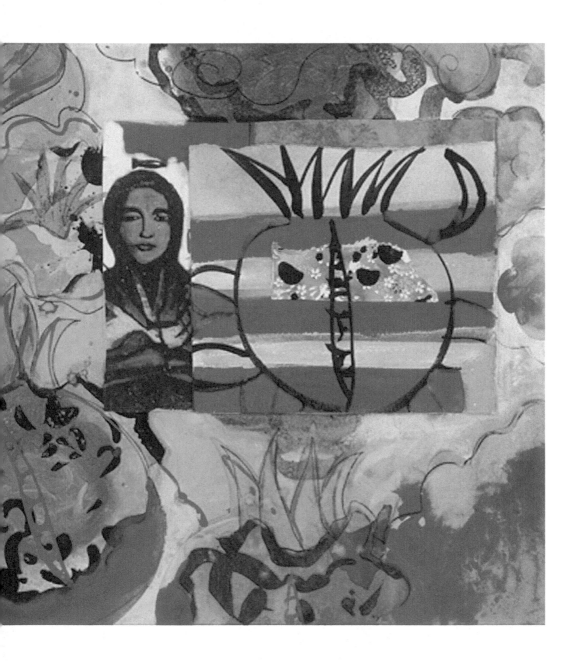

DIANNE BOWEN

NEW YORK, NEW YORK

TELL ME EVERYTHING

Various papers, wire, found objects, artist book size variable depending on page

ANN FIRESTONE UNGAR

NEW YORK, NEW YORK

WEAPONS OF DISARMAMENT:
VAN GOGH/ARLES & PICASSO/GUERNICA

"Vincent's Bedroom in Arles" 1888
as he paints it
is spare
is clean
is full of light.
"The walls are pale violet.
The floor is of red tiles.
The wood of the bed and chairs is the yellow of fresh butter,
the sheet and pillows very light lemon-green.
The toilet table orange, the basin blue.
The doors lilac."
The window
bringing natural warm illumination –
no shadows,
though Vincent says "this room with closed shutters."
A place of repose
despite his anxiety –
a refuge,
this, a place of peace.

Picasso's "Guernica" 1937
as he paints it
is a room of horror
of agony
of death
of grief
in black and white and gray:
the reaching man in stylized flames -
the severed arm still holding a broken sword -
those running from bombs into this room of ruin
with a torch of sorts (hope?) -
the hysterical horse -
the mother screaming to heaven
as she holds her dead child -
the artist as flat bull
observing this room
created by war
where light is jagged and artificial
a naked bulb
hanging there,
a human creation
as is war,
a siege of despair
a dubious refuge of angles
where shadows jut
and menace.

Van Gogh/Arles
Picasso/Guernica
Contemplate the choice.
Contemplate the choice.

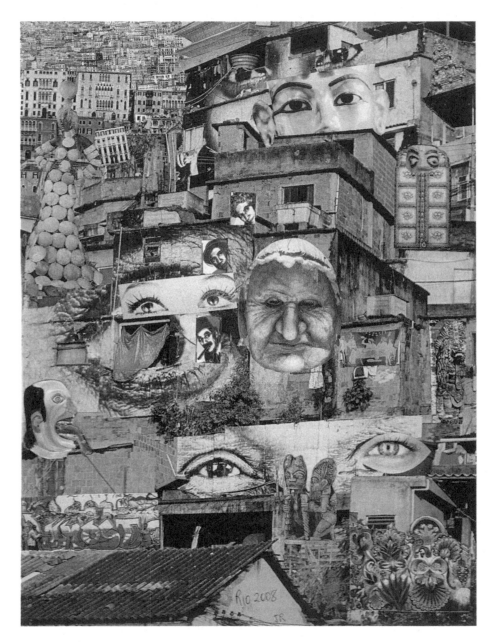

MARX BROTHERS

Collage on paper, cut outs, 9 x12 inches

VALERY OISTEANU

NEW YORK, NEW YORK

DADA NOT ON TOUR!

Supra Dadaists flagellate the milk-ghosts of imposters
A hundred years ago in a bird's cemetery
Inside a fluid-skeptic clock deep in a dark fish-tank
Outside of the dolphin's underwater cave-temples
With Tsar Tristan, dada daddy of simultaneity
Broken dada without borders, japonodada
Occulti-dada portal into the planetary sagacity
De Quincey was dada, Alfred Jarry the prophet
Tristan Tzarathustra shouts disgust, imagination
On the other side of the train-of-thoughts tracks
"Not a great night at Voltaire, too many dada-ists!"
 Swiss bourgeois derogatory put down label: "dadaisten"
Dada a mind exercise of free associations
Revolution encompassing sex, drugs and art
Dada is nada, just a backward time traveler
A chance on purpose illusionistically mislead
Tempest temple templar is not a cult, it's the noise
Anti-life lifestyle bottled throughout human silence
Self-destructive, déjà jadis, lost in the past
Dada is spiritual fiber optics, synoptic synapses
Defending the devastation of the seas
The uber-coincidence could not be televised
Transgender mannequins on ceramic bicycles
Invisible acrobats flying over the limpid wind
Neo-dada not sponsored by the Menza club
Dada Not on Tour! Dada eludes cultural poachers
Were you in an art coma during last century?
Resistance to hierarchies, radical sub-consciousness
You probably woke up as a post-surrealist
Analog artist in a digital dada-world
Smash bipolar dementia of the art market
Of tyranny, of unachievable lugubrious prices
Occupy centenary of uncompromising art
Occupy the impossible, misunderstood dreams
A mix of trance and brain miasmas
Approximative woman's tranquil-i-dada
Mysterious emotions after discovering my muse.

WILLIAM SEATON

GOSHEN, NEW YORK

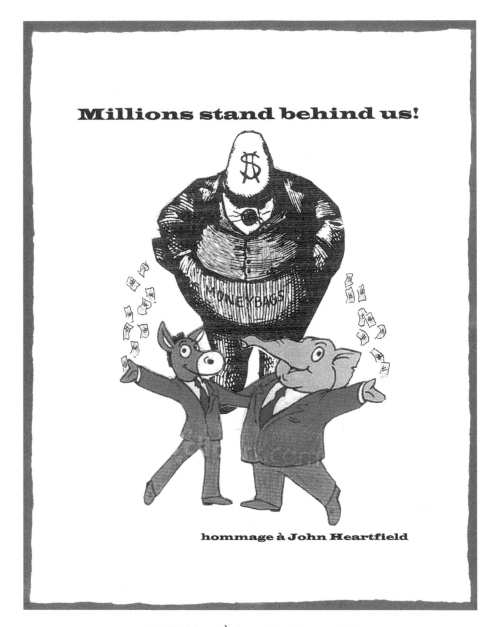

HOMMAGE À JOHN HEARTFIELD

Jpg

DYLAN KRIEGER

BATON ROUGE, LOUISIANA

BOMB COUNTDOWN

they say that in the — knick of nightmare

t i m e s l o w s d o w n

to fit whole lifetimes — into a flash of lightning—

but how does that — explain the extra hours

it takes to fight — them off before rewiring?

blue, green, yellow — when a hero trusts no one

everything goes red — as in danger! / recording

quit it if you — wanna keep your vision

of the apocalypse — in which you win yourself

a kingdom in the — devastated after-globe

since as a species — we tend to worship

slave-masters — prescient solvers of

their own disasters — prison war/dens

made of plaster— — hurry, cut the cord!

but what is it we're — chasing after? if the

heat doesn't get us — the impact sure will

if the people don't blow it — the asteroids will

the fucking rocks will cry out — & say there was a hero once

who took a whole planet — & made it his crutch

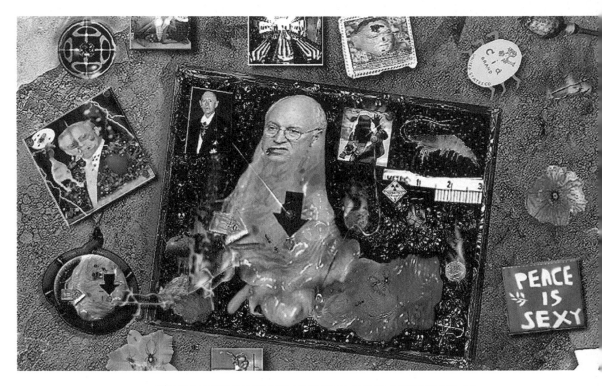

PENTAGON OF FLIES UNDISCLOSED LOCATION #1

Digital collage

" ... We used authentic shots of war, of the
heads of Europe, and the like. These shots
flame thrower attacks, piles of mutilated
yet come into 'fashion,' so these pictures
on the masses of the proletariat than a

SCOTT WANNBERG

1953 – 2011

OOH LA LA

I saw Dick Cheney fucking a nuclear warhead on the hungry channel

his dick fell off and turned into a terrorist

the right people for the right time

ran in and saved us all

sure, there's a little blood in your wine

but it is red wine and nobody need know

all the so called giants i've ever known

they all started out small

oooh la la the executioner says

before his axe falls

show me to the hammock

i don't know me anymore

tonight i hope it snows

i'd build a big man

and roll it down some hill

oooh la la i heard a cardinal sing

my guide book has given up the holy act of reading

demobilization, of a parade of all the crowned
brutally demonstrated the horror of war:
bodies, burning cities; war films had not
were bound to have a more striking impact
hundred lectures." — John Heartfield

JOHN J. TRAUSE
WOOD-RIDGE, NEW JERSEY

ON THE HORROR, FUTILITY, AND ABSURDITY OF WAR

Gaugamela
Chickamauga
Chattanooga
Chapultepec

Gaugamela
Chickamauga
Chattanooga
Chapultepec

Gaugamela
Chickamauga
Chattanooga
Chapultepec

Gaugamela
Chickamauga
Chattanooga
Chapultepec

Gaugamela
Chickamauga
Chattanooga
Chapultepec

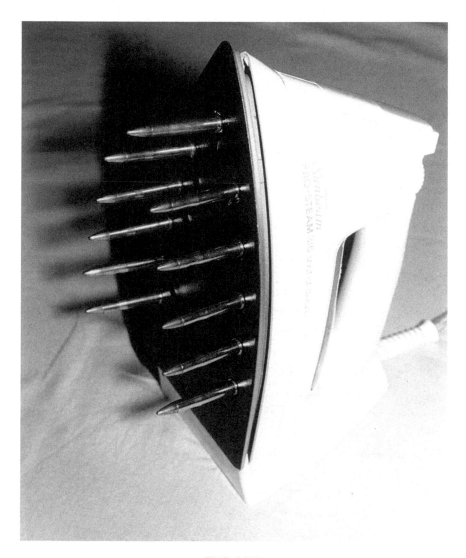

THE GIFT

In Man Ray's Cadeau (Gift) made in 1921 and reproduced in 1958, a painted flat iron has a row of metal tacks glued to its front. This makes it suddenly both useless and dangerous looking, defying function and meaning, with its title "Gift" mysterious. This kind of iron needed to be slowly heated on a metal stove, or equivalent, to the right temperature so that it would smoothe cloth but not cause burns.

Seventy six years later, in 1997, electric steam irons are standard. Place a .22 Hornet bullet in each of the steam holes. The effect is shocking. All the viewer needs to do is to plug the iron in and turn it on. Will the bullets explode, or fire forward? The title "Gift" now seems like a threat. Dada was never made for niceties.

"To create is divine, to reproduce is human." Man Ray, in "Originals Graphic Multiples," circa 1968; published in Objets de Mon Affection, 1983.

Electric steam iron, with .22 Hornet bullets. One a/p 1997, signed and editioned on base. Edition of 3 declared in 1997, made in 2015.

DOUG KNOTT

LOS ANGELES, CALIFORNIA

GAMBLERS FROM THE INSIDE

I never play video games

And stopped playing cards

Although I have a friend who bets

And remembers every card in 4 decks

but teaches school to back it up;

And another who plays poker

Only at 4am in all-night casinos when the dumber guys finally show

Like them, I gamble conservatively—

I'm playing to get off this planet with clean hands

But how to do that if I'm invested in Chevron?

And we all drive roads, make calls, run computers

And enjoy electric-eye automatic toilet flushes

We're eating on the system and that's how it is,

All together at the gambling table in spite of ourselves.

It's 4am and going to be a hot day.

BOB BRANAMAN

LOS ANGELES, CALIFORNIA

UNTITLED

Etching

ANNE WALDMAN

NEW YORK, NEW YORK

HANNAH TAKES OUT HER SCISSORS

Insolence and the lovely life of

A Hannah Hoch

A rankling of affinity

Girl moods

My old rigor, my girl

Distort head & sex

Roll over

The moon the moon

See?

Fragmented the truth serum

Marx happened

Existential better be your mother

Idiocy of the curl

Churlish lip

A chuff and a chin curls

Ivory spurt

Da-Daddy

Silks and a pattern

Lesbian moonlight

You only offer sandwiches beer and

Coffee? the cruel Richter

The married Raoul

Men on the slant

A chase for origins

Spools, clansfolk, adherents

Surprise!

Got Hong Kong blues?

You could be a fashion plate

Cut the A lines

Then the fish

Architectures break down

Come see me in your cutting mode

A small street in old town

Rattling vehicles

Fish heads for sale

Shopping as a guise

Checking out investments

Vestibules relegate the downturn

Collecting culture on a downswing

The little pieces of paper! Aha!

On the verticals

Crass deformations

Caress my transient metabolism

The new multi-territories of identity

I will vote only in my anarchist bones

Skin over, sing over the melody

Bring the vocals up,

My bone my bones, bring them on

Abrupt denials tension

My larynx hungers for your not not-art?

Are you not-culture? Not you?

What are you?

Knot of Hannah, wired to montage

This is my camera: China

Hannah leaves the café

Warmer, less hungry

She goes into zone B

Traffic where zone A is all cars

World War 1 is a Red Cross

My fellow sisterly feeling

Then I go into exile, dear girl

My exchange for Mao money

Don't speak for my world, World!

Is news fascination?

Can she travel? She will stay in Berlin

Nazi down the block

Hannah hocks the tribal feeling

Hannah takes out her scissors

Punishing fears of rhythm dominance

Cut cut the ghosts

Cut cut linear time

Cut modernity!

Cut the men who dissolve

Birds & wings & snakes

Cut cut cut

Artifacts resume power and

Prevail to alter a work station

Music elevated to the

Fetish on a badly missionized street

Are you memorized yet?

Memorialized?

Is intervention a plus for you?

Skip rope, and hope hovers

Then you're bodied

You are hooded

Waiting for the ax to fall

Get high up, don't make it be all you!

About the money, about love

Waiting for flood relief in the dark age

Encounter a detour, a woman's glove

Memory needs objects

Mountains are frozen waves

Image de la Chine?

We overlap you, my girl

Alive in my roaring time frame

Text your observers my way

Need better reportage

Your salvaging status, Hannah

Held in the lockdown

On the wildlife

Oral tribes in your astrology chart?

Gunning & truck lore?

Today it's also armed trucks
Border patrols. Armed vigilantes
Lockdown, mass death
Today it's a critical mass
Of violence and suffering
Document sent for "too few"
Immigrants, no room
The sunshades give silence
But wake up the sleeves!
Uncoil Berlin!
Germany welcomes you!
Uncoil New York
Are you vertical?
Empire of cutting up China
Un-reconcilable
Mantra of cut cut
Don't violate city anthropology Ha!
Text your massive hope: 2016
We learn from you
Images not sacrosanct
Epic rainbow struggles
Lost in shoes a global destiny
Dust my bin
Then get out of my way
Headband regalia?
Starve the puritans, rattle their cages
Will guide you
Loop waver fork
Don't mimic the lost bodies
They need your cut cut deranged eyes!

AW/from "Future Feminism"

DEREK ADAMS

SUFFOLK, UNITED KINGDOM

CREDIBLE

after U.S. Military Intelligence Statement

We have
good reason
to believe
that there is
a high probability
that our intelligence
is credible.

SUZI KAPLAN OLMSTED

OAKLAND, CALIFORNIA

WARMONGERS

Fuck You Hitler
FU Reagan. FU Bushes,
FU Stalin, Franco, Peron,
Kissinger, Pinochet, Pol
Pot, and Idi, fuck
you too. Fuck U Republicans,
ISIS, Al Qaieda, & Taliban
Rumsfeld, Cheney,
Trump, Fiorini most of Congress & Putin,
Go Fuck Yourselves
cause no one else (sane)
 will fuck you
Get fucked up the ass
by the
stump of a child soldier
who will laugh & laugh
while you bleed

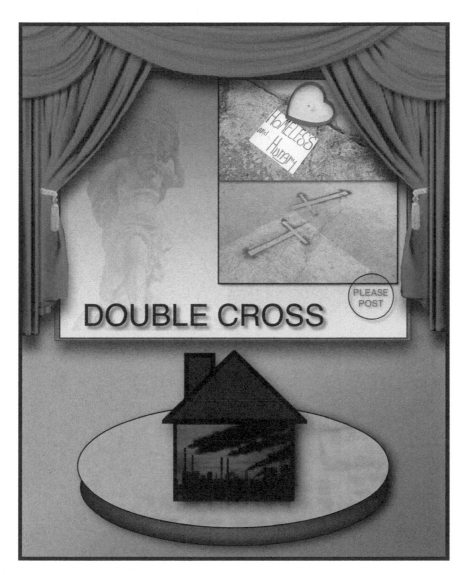

DOUBLE CROSS

Photograph & digital graphic

JANE ORMEROD

NEW YORK, NEW YORK

MAYBE THERE IS A DOCTOR IN THE HOUSE

This is ultimate intelligence. Perpetual islands of desolation sold to strangers within the shake of a small tail. You are slim, you are a bull, you float, swing, are old, red, a bachelor of science. Maintain that to-ing and fro-ing, keep on your toes when returned to the soil. This is no safety exercise. Command your astonishment. Surprises need two hours, require auto-destructive sleep. Not all secrets are top. Some need a base, a fair idea of motion skill. But motion is dead. Nothing at all is what you like. Do what you like with peace. Conclusions appear pre-fixed. Watchful. Combustible. Stopping peace by professing peace. Variations on consumption as merry ever. The best of less of conclusion and luck and lock. The stinkworm of wrong-way news. Gulp alcohol, rainwater, dropkick orders. Check rectangles and triangles for missing degrees. There are a lot of men. Gold. Sure as hell and airborne. Programmed men smoking suppression. Counting the destroyed, the uncoordinated truth. Choose between Vegas and poached eggs, a surplus of lipstick and library. The head packed with gum, buffoonery, spit, washing machines, Coke machines, misaligned buttons. Can you claim to be strategic? Can you crawl faster than you walk? Do you enjoy soup more than ice-cream memory? Do you enjoy fun? Do you enjoy answers? The back of your neighbor's head? A bell misheard as a no?

"Dada doubts everything. Dada is an armadillo. Everything is Dada, too. Beware of Dada. Anti-dadaism is a disease: self-kleptomania, man's normal condition, is Dada. But the real dada's are against Dada."
— Tristan Tzara

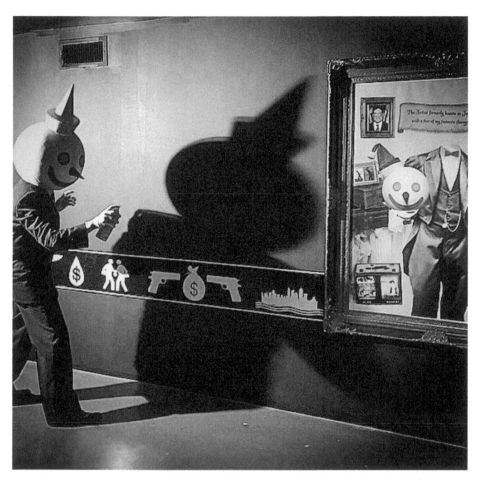

JACK'D IN DA HOOD

composite collaborative between Phantom Street Artist and Jim McHugh

The Phantom Street Artist is a radical performance artist which questions our Kulture in question. Named as the Phantom Street Artist who has been a longterm critical commentator and journalist for many editors, media outlets and publications. This internationally-recognized street artist and album cover artist for Rage Against The Machine founded Art Saves Lives and its independent media channel, PYR8FREETV, which heroically critiques our culture through its cause-based campaigns of social inquiry. The Street Artist in the past has authored and created photo projections at the LA Cathedral in defense of the many indigenous children who were victimized and abused by the Roman Catholic clergy as youth. The Street Phantom was one of the select street artists who protested Jeffrey Deitch's 2011 MOCA survey of graffiti art with its revised title, "CA$HING IN ON THE STREETS. The Street Phantom has been a longstanding force in the LA street art scene where he first began piecing and tagging on the MTA subway platforms of NYC with Caine One.

MARC OLMSTED

OAKLAND, CALIFORNIA

GIVE ME THAT SCI FI RELIGION

Mad Max is the new bible

"The future belongs to the mad"

Buy a ticket for 3D adrenaline

only the movie doesn't stop

"Max. My name is Max."

I live in Oakland,

city of concrete

and blood.

The middle class is a wooly mammoth

The reptiles return, smarter

& very rich

Jurassic Galaxy coming

to a space colony near you —

Except USA now gone, consuming itself

until every TV show was about zombies —

War never ends it just changes parties

This one has more babes, that one — more blow

If you hurry, you can make both.

"Max. My name is Max."

This is where I came in.

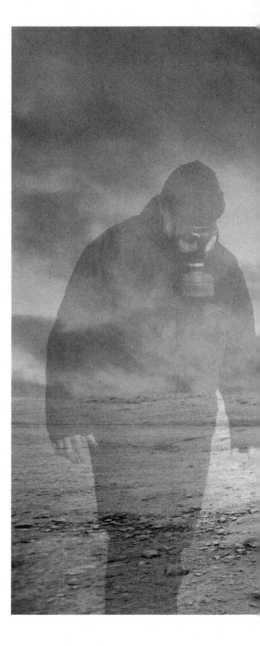

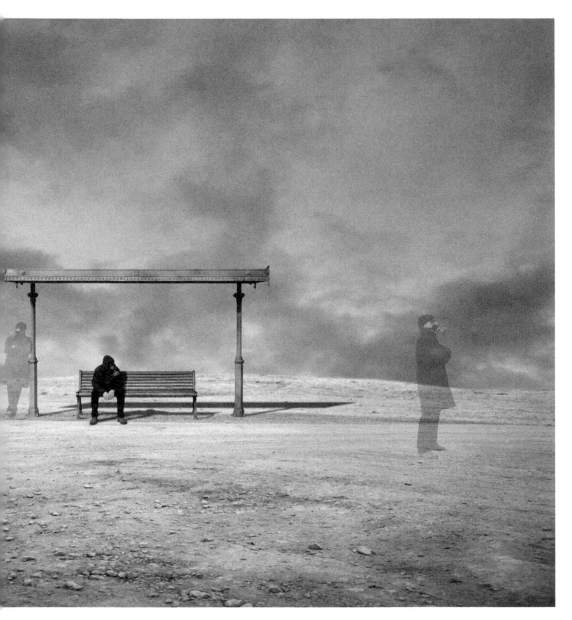

WAITING

Print on photo paper - 70 x 50 cm

THOMAS FUCALORO

STATEN ISLAND, NEW YORK

W(ARM)----HU(N)G(ER)

Rising is changing to risen.

Float in a boat made for sailing.

I am a boat made for swimming.

Come upon my sailed shoulders

let the wind blow

nuclear hazardous

pink stardust

every wear.

I am David Buoy.

This nuclear hazardous

pink startdust

transforms

into 8-legged ligature.

You are my spiders.

You are my crawling

around my neck.

Hung.

These spiders

have arms.

THOMAS STOLMAR

SAN FRANCISCO, CALIFORNIA

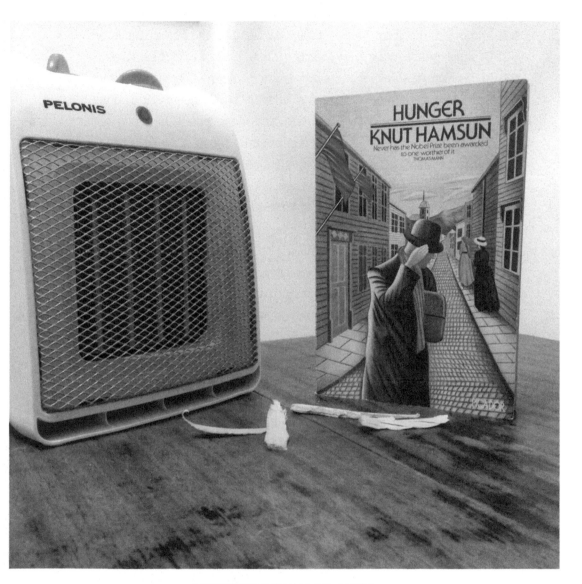

LET THEM EAT WOOD CHIPS

Digital photo, 63.717 x 223.111

ALI ZNAIDI

REDEYEF, TUNISIA

PLANET DADA EARTH

01] Drought, continuous. They sow bombs. Reject words. Atomic dust.

02] The world, reduced. Archive of agony. Death in the fields. Disasters.

03] Drunken bees. An array of shards. Robes. Line of microbes. Greed.

04] In the blink of an eye a bacterium formed. Meanwhile, violent attacks.

05] Dead trees. Fragments of people. Leaves turning colour. Arid zones.

06] Bones without marrows. Eczematous ozone layers. A bonus.

07] Caws of crows. A very sweaty winter sun. Smoke, a cause. Thunder.

08] Echoes of garbage. Empty dams. Insatiability. Death comes. Lightning.

09] Radioactive paradise. Duplicate chaos. The grace of decay. Clowns.

10] The picture of grey towns. More fragmented selfies. Less fertile clouds.

11] Noise, silenced. Mouths, zipped. Greed at its zenith. Loans. Loans . . .

12] A (black) birch twig instead of an olive twig. No forks. No spoons.

13] Knives, sharp. Sharpening of the teeth. Articulate the fang. Capitalism.

14] Modified cells. A lot of errors. Distorted, discourse. Thru terror(ism).

15] Hunger, hunger, hunger. And nothing in between. Acid (rare) rain.

16] Worms abound in silent forests. Guests of fear and loathing. GREED.

17] Things, lost. Recluses. Nostalgia for Emersonian perfectionism. Thirst.

18] [This content is prohibited]. [404 Page Not Found]. [Never Found].

19] Buzzing flies without a lord. {Freedom!!!}. Destruction is incubating.

20] An array of zombies oscillating between life and darkness. Dim darkness.

21] Cold war. Sundown. Cold sun. Sunrise. Warm wars. The sun also rises.

"Dada is the sun, Dada is the egg. Dada is the Police of the Police."
—Richard Huelsenbeck

BECKY FAWCETT

LINCOLNSHIRE, UNITED KINGDOM

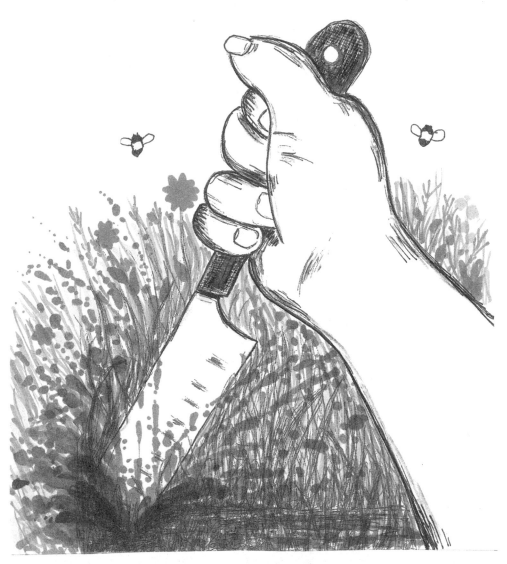

EARTH KILLER

A4 paper and drawing pen

GEORGE WALLACE

HUNTINGTON, NEW YORK

A NATIONAL ANTHEM

This is my patch of green
I have mortgaged my life for it
I have given up my dreams
I have slid up and down the
Rotten flagpole for your crummy
Wages, for your endless stream
Of sexual provocation and
White privilege and false
Propaganda and materialistic
Bullshit — your low interest rates
And breast enhancements and lipstick
Your easy riders and perfect 8x10 lies
I have rocked your cradle and robbed from it too
My patch of green my patch of green
I have eaten napalm from it
And fetched and carried
and been kind to strangers
And got out of jail free
And did not covet my neighbor
And his condominium of wives
 I have fucked you and upped yours

My patch of green, I am your slave,
master, addict, queen — I am your
Man, I lift up mine eyes and set them
Down again like a toilet seat — and I have
Purchased a shotgun and put it to my mouth
And prayed and prayed and masturbated into
The cavernous hole of its one good eye —
I have trampled out the vintage —
Spit drool come and blood —
Smeared my name on the holy
Bureaucracy of your magic flag —
I've puked you up, you! into your
Open skull — and commuted and
Cried and wiped my mouth
And come back for more —
Mist rises from the graves
Of rich and poor alike — soldiers
Of fortune spiderweb spinners
Materialistic black widow mistresses
And denizens of the lazy light show —

O bowels of earth, o beanfield and immigrant ship,
This anthem is for you and this anthem has no memory —
I am up against your wall again Motherfucker — your cabanas
And cops your country clubs and car dealerships
Your titty bars and strip malls and mighty soul explosions

I love you, Dear Agent Provocateur, Purveyor of Heteronormative Bliss

Pour me a drink
I am hooked on you

WESLEY RICKERT

LANSDOWNE, CANADA

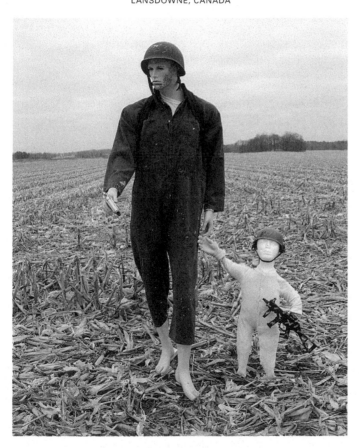

THE FLOWERS OF SPRING

Digital photograph, 4 x 5 inches

AIMEE HERMAN

BROOKLYN, NEW YORK

forgetting how permanent
 blood stains can be
when pulling on the trigger
of a trigger warning

"destruct a toxin made of quinoa curled cabbage grapefruit squeeze
 ozone-dried tomatoes disseminate carbohydrates immediately"

see section 119, paragraph 52:

- any weapon, be it ancient or classical, intended to cause symptoms such as phantom limb or gutting

- ill-intentioned driptorch, Meng Huo You, cocktail of Molotov

- excessive erasing / hijacked wrinkles through bacterial botulin

- to cause serious bodily injury through distribution of phosgene, acrolein, overindulgent posting of selfies

- any weapon involving a bullied mock, pierced tongue painted with biblical verse rearranged to hate and /or of or relating to tears gassed and blinded

- any weapon designed to release twitch, side-effects of agoraphobia, eleutherophobia, phronemophobia, euphobia, dikephobia and lutraphobia

- and of such profiling caused by beard length, gender disintegration, holiday observance, musical inclinations, favorite color, favorite yoga position, allergies, vegetarianism, webbed toes, unpronounceable middle name, waist size, freckle amount, and/but not inclusive of online dating profile, inability to understand Powerpoint, and any discerning accent

see also:

1. abundance of student loan debt coupled with wallet weight loss

2. bed sores derived from Fox news choke hold

3. post-traumatic stress disorder due to Republican presidential candidates

4. loss of appetite of brain from fracking

5. introduction of villains called: Hurricane, Flood, Spruce Bark Beetles and Donald J. Trump

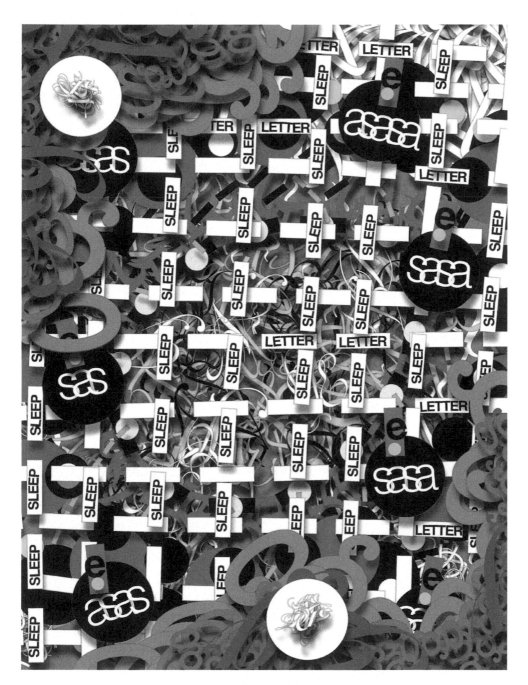

LETTER SLEEP

Digital letter composition

W.K. STRATTON
ROUND ROCK, TEXAS

STATISTICAL DISTRIBUTION

The day you wilted, fire trotted southbound
Through abandoned limestone quarries
Ringed with fishbone and buffalo recall.

A bloodied sun beckons the north now.
I am alone.
I line the skins you shed along fallen wires.
This is the limning of unheeded woe and smoke.

Seas scrub Nebraska, as in epochs hidden.
Shall we be reclaimed as fossils?
No, we are soil that sprouts nothing.
Twenty-first century foam claws. . . .

On the screen women danced out porn.
In the room men reclined with legs removed.
At the door children hoisted bitcoins.
They were accustomed well.

Now I lay me down in realms of ash and saltwater.
Change in the weather, baby, oh yeah yeah yeah.
No more sleek rooms and midnight hums.
Better tune up and sing these blues, old man.
Your time is rust shattered. Harvest you now
Jaws of plastic and sludge but expel nothing.
You are defunct in evening traffic exhaust:
Lost recuperation.

GIOVANNI FONTANA

ALATRI, ITALY

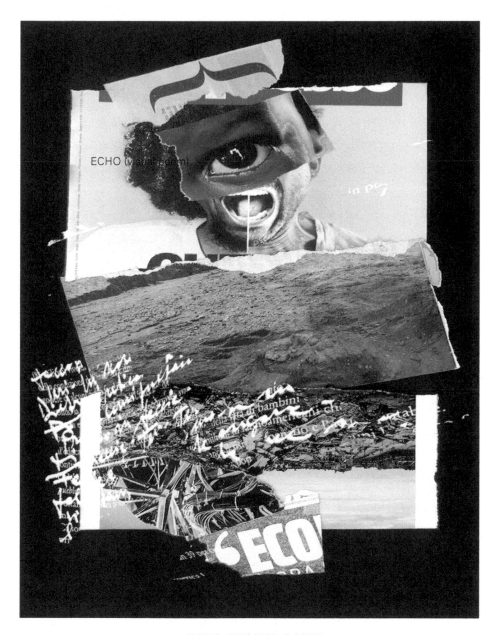

ECHO (VISUAL POEM)

Collage & ink; 10,6 x 12,7 cm

ANTONIA ALEXANDRA KLIMENKO

PARIS, FRANCE

HYSTERECTOMY OF MOTHER EARTH

My own darkness pulls the cord I am the barren box I sit in—
refrigerated silence of jujube babies—eyes sucked dry like eggs
from the hollow middle Grief enters me like a knife and stays to haunt
The exiled cries of the unborn file through me in anonymous procession
while Heart beats the drum

Deliverance Again and again I perform the operation—
the soul of a new day tugging gently at my sleeve
They cannot anesthetize me suffciently to sleep through Death
I must see you hear you feel you be you
Life is someone else's pain It is only Death that is my own

Death wraps you in a cellophane smile and saves you for later
like other brown-bag yesterdays And then you carry him with you
all day long and you starve the curse of an orphan

Life is removing the darkness from within
Always calling Her by name
The petal of roses opens and closes
These are my parents who are my children
It is for you that I will not hunger

ADITYA BAHL

BILASPUR, INDIA

A COLLAGE

Digital art

BAAM aka MARIA GARFJELL
SALTSJÖBADEN, SWEDEN

HOMAGE TO A COW'S DIARY

Woke up. Ate. Looked out the window.

It´s snowing. In June.

Got milked. Feels nice.

My udder itches. Wish I had hands.

Farting.

Rosa was taken away. She will be meat tomorrow. Unless she´s trampled to death.

Then she will be glue. Or make-up. Or dog food.

Farting.

Looking outside. No grass. The snow is melting. It´s June.

Got milked. My udder´s bleeding. Ate.

The feed concentrate is for dogs. Slept.

No room to move.

Farting.

Got milked. My udder´s still bleeding.

The milkman looked at me. Angry. Shook his head.

Itching.

A yellow note on my box.

Got an injection.

I will be meat next week. If I´m not trampled to death.

Then I will be glue. Or make-up. Or dog food.

Farting.

KAREN HILDEBRAND

BROOKLYN, NEW YORK

THE GREAT MILKY WAY

I have many reports
on the miseries of the milkman,

daughter of dairy folk that I am.
But the cows! The cows are lovely

creatures! Holstein, Guernsey,
Belarus Red. I remember the way

Uncle Vern used to hook them up
to milking machines that pulsed

the barn like a disco. Milk!
It's my happy place! Butter

churned from the froth!
Takes well to chocolate

and mama's boys.
It's the sweet bond of suckle

we wish we could return to.
In a bowl the Cheerios

always run out first.
Snow White, a shapely vixen,

bottled with a pleated cap
and wholesome as Nancy Drew.

"Farming is hard," said Uncle Vern
before he died. "Damn you,

Vern," said his wife, after.
When he was sad, he ate

Wonder Bread soaked in milk
from a glass with a spoon.

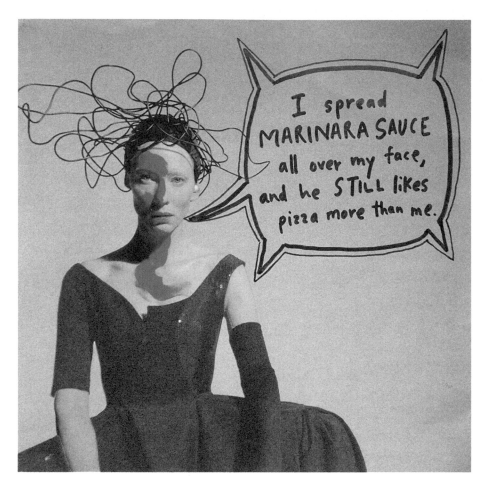

MARINARA SAUCE

Digital collage

CATHY DREYER

GINGE, UNITED KINGDOM

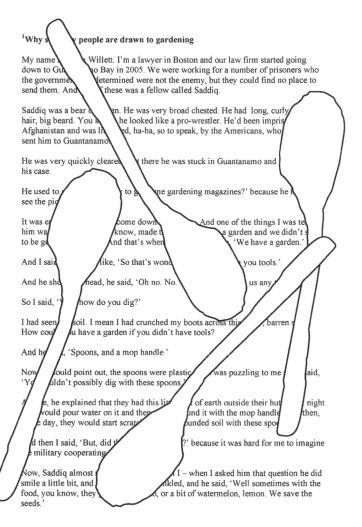

[1]Why s y people are drawn to gardening

My name Willett. I'm a lawyer in Boston and our law firm started going
down to Gu o Bay in 2005. We were working for a number of prisoners who
the governme etermined were not the enemy, but they could find no place to
send them. And f these was a fellow called Saddiq.

Saddiq was a bear an. He was very broad chested. He had long, curly
hair, big beard. You he looked like a pro-wrestler. He'd been impris
Afghanistan and was li ed, ha-ha, so to speak, by the Americans, who
sent him to Guantanamo

He was very quickly cleare there he was stuck in Guantanamo and
his case.

He used to to g me gardening magazines?' because he
see the pic

It was e come down And one of the things I was te
him wa know, made t a garden and we didn't
to be g And that's when 'We have a garden.'

And I said like, 'So that's wond you tools.'

And he sh head, he said, 'Oh no. No. us any

So I said, ' how do you dig?'

I had seen soil. I mean I had crunched my boots across thi , barren
How cou u have a garden if you didn't have tools?

And he , 'Spoons, and a mop handle.'

Now ould point out, the spoons were plastic was puzzling to me aid,
'Y ldn't possibly dig with these spoons

A e, he explained that they had this lit of earth outside their hut night
vould pour water on it and then nd it with the mop handle then,
e day, they would start scrate ounded soil with these spo

d then I said, 'But, did t ?' because it was hard for me to imagine
e military cooperating

Now, Saddiq almost I – when I asked him that question he did
smile a little bit, and kled, and he said, 'Well sometimes with the
food, you know, they , or a bit of watermelon, lemon. We save the
seeds.'

[1]From The Why Factor, *BBC Radio 4, Wednesday, 11 November, 2015*

WHY SO MANY PEOPLE ARE DRAWN TO GARDENING

Collage

PATRICIA LEONARD

YONKERS, NEW YORK

HUNGER PANGS

When I'm hungry I can do it all. I can wrangle down a goat or lamb double my weight, hang it by its legs and cut through the jugular while I watch it breathe its last few breaths of life. As it screams, I wash the blood down the drain or if I want the blood, I hold the head while aiming the blood into a bucket. Afterwards, I skillfully and artfully skin its entirety with swift movements of my sharp blade. I start at the back of one leg a little above the ankle. I cut around the leg but not in too deep. There is a sweet spot on the inside of the leg that will allow my blade to cut through the skin like scissors to wrapping paper. I cut all the way through to the anus. I repeat the process on the other side meeting in the middle. I make a light slit down the stomach all the way down to the neck. I typically start on the left side because I am right-handed. With my left hand I start to pull away the skin from the flesh while my right hand guides the knife along the inside of the skin careful not to puncture any fat or meat. When I am all done removing the skin, it is time to remove the head. This is done by snapping the neck and cutting through the muscles and tendons. It is then carefully slit by the belly without bursting a hole on any of the inside organs to remove the stomach along with the intestines. The organs that are left after are the liver, kidneys, lungs and heart. After carefully removing the bile duct without rupturing it, the organs can be safely detached. If the gallbladder burst onto the meat, it will be spoiled and inedible. This step separates the amateurs from the professionals. The heart and lungs are carefully removed with a quick slit while still steaming hot, being as gentle as one can be.

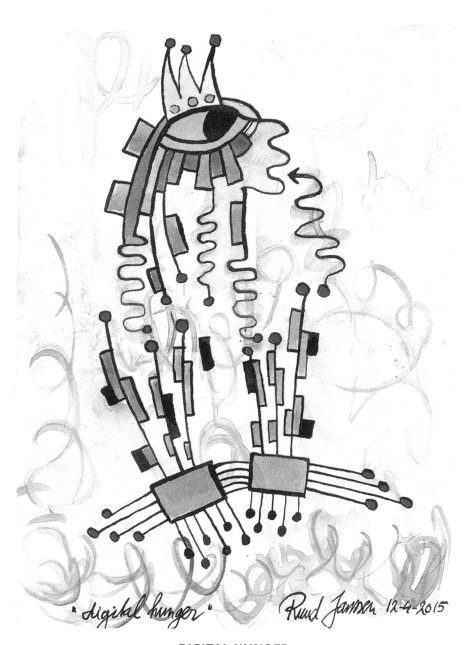

DIGITAL HUNGER

Drawing; India ink and watercolour
(From the series Digital World - Analog Human)

IULIA MILITARU

BUCHAREST, ROMANIA

E.A.T.

1. eatMeat

Meat is the best food ever. The doctor indicates it. The

Meat consumption increases your brightness and helps the balanced growth of your body. Most of the communities that don't eat

Meat are retardate.

Meat is very useful in many types of Bantings. Altogether, the

Meat supplies are different kind of inhabitants, domestic or natural wild, according to their own time and place. The difference consists of taste, tenderness and amount. The famine of

Meat is very dangerous. One can contract many types of disease because of it. That's about all on

Meat, good people!

2. Action

26th January 1947, Besalia Village: The citizen Ciacu Gheorghii Gheorghievici (born in 1912), a poor peasant, butchers his daughter (born in 1940) and eats her instead of food.

28th January 1947, Besalia Village: The same subject butchers his son (age: 5 years old). A part of the body will be eaten by him and the other part will be sold in the marketplace.

3. The End

Conclusion: *All muscle tissue is very high in protein, containing all of the essential amino acids, and in most cases is a good source of zinc, vitamin B12, selenium, phosphorus, niacin, vitamin B6, choline, riboflavin and iron. Several forms of meat are also high in vitamin K. Muscle tissue is very low in carbohydrates and does not contain dietary fiber. The fat content of meat can vary widely depending on the species and breed of animal.*

ANGELA CAPORASO

CASERTA, ITALY

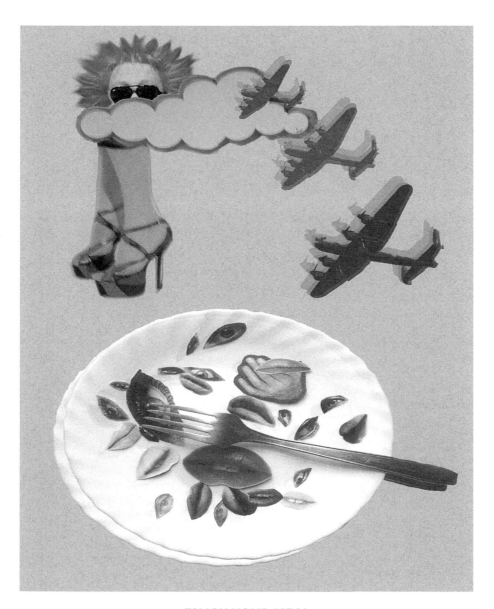

ENJOY YOUR MEAL

Collage

JAMIKA AJALON

PARIS, FRANCE

from ON NIHILISTIC ADVENTURE (NOTATIONS)

I (in the beginning)
WHEN I (WE)
CRASH FINALLY
STARS WILL SPREAD
FOR AN INSTANT
INDELIBLY MARKING
SOME CEREBRAL SCREAM
PERMANENTLY ON THE FACE/ OF 'REALITY'

II (material world)
POSSESSIONS/A BLINDING-FOLD/BARRIER
TO EXTREME (CLOSE-UP) PROXIMITY TO THE STREET
RENT UNPAID/NO FRIENDS FAMILY TO SPEAK OF/A BED ON THE CURB
DOORSTEP HOVEL SIDEWALK/ANY COMBINATION OF THESE FINE SUB-GROUND/
SUB-CLASS ACCOMMODATIONS

III (still life)
PRESSURE/EROSION/SLOWLY/SUBVERSIVE/STILL FEEDING
HOLLOW BONE/INJECTING DISEASE/MUZAAAK/TRANSFORMING THE "MASSES"
INTO NUMB PITTED OPERATIONAL JELLY BABIES
MINIMAL NECESSITY FOR OPTIMAL BRAIN SOAKS
SKINNY DIPS IN MEDIA
BLITZES/JUST ENOUGH
PRETTY PICTURES ON OFFICE (CUBICAL) WALLS
AND ONE SLIT ON
THE DARK PAINTED DOORWAY
ONE SLASH OF LIGHT
DRIPPING RED

DOBRICA KAMPERELIC

BELGRAD, SERBIA

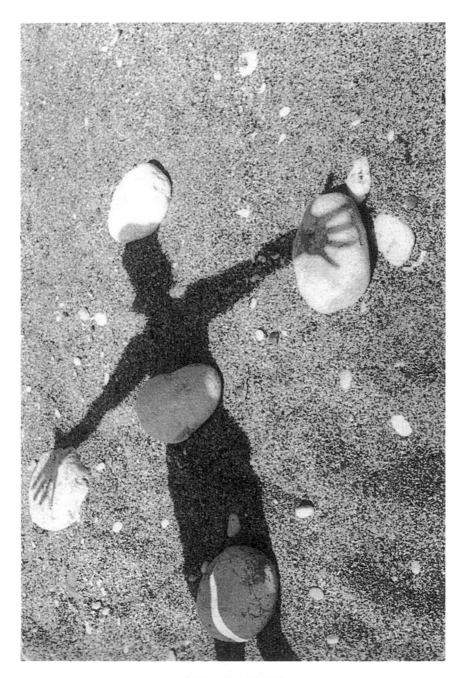

DADA SHADOW

Photograph

ALICE BAG

LOS ANGELES, CALIFORNIA

POISONED SEED

There was a time this land would yield a fruitful bounty
Amber waves of grain could inspire a song
But the winds of change have blown
And things have gone terribly wrong

Tossed from his hands, scattered on the land
He had the harvest carefully planned

I'm not going to water the poisoned seed

Flying on a breeze, spreading the disease
He's gonna squeeze 'em until they bleed

I'm not going to water the poisoned seed
I'd rather be to my neck in weeds!

Those heirlooms were like gems
But now it's coming to an end

I'm not going to water the poisoned seed

Oh we were blind, trusted in the science
Planted the crop and fell in line

I'm not going to water the poisoned seed
I'm not going to water the poisoned seed

"I wish to blur the firm
boundaries which we
self-certain people tend
to delineate around
all we can achieve."
—Hannah Hoch

ALEXANDER LIMAREV

NOVOSIBIRSK, SIBERIA, RUSSIA

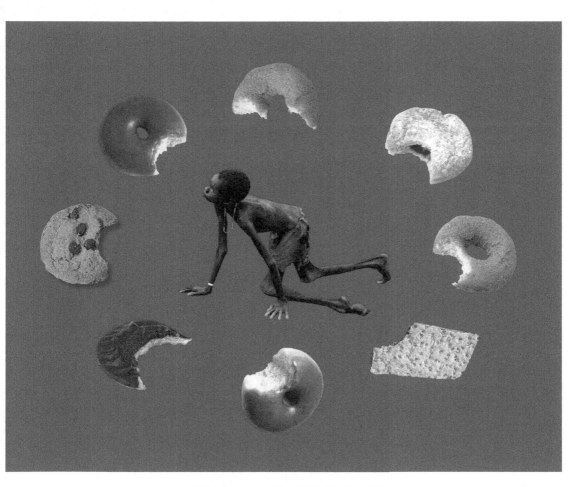

LET'S FIRST FEED THE HUNGRY

Digital collage

MICHAEL T. FOURNIER
BELCHERTOWN, MASSACHUSETTS

HEADLINES SCREAMING IN MY EYES

IN
MY EYES
HEADLINES
SCREAMING IN
MY EYES HEADLINES
IN MY EYES SCREAMING
IN MY LINES SCREAMING EYES HEADLINES
SCREAMING LINES EYES IN MY HEAD LINES SCREAMING
EYES IN MY HEADLINES SCREAMING HEADLINES SCREAMING
HEADLINES SCREAMING IN MY HEAD EYES HEAD LINES HEADLINES EYES
SCREAMING HEADLINES IN MY EYES SCREMAING HEADLINES IN MY EYES
MY EYES MY EYES SCREAMING HEADLINES IN MY EYES SCREAMING MY EYES IN
IN IN IN IN IN IN IN IN IN IN IN IN HEAD IN IN IN IN IN HEAD IN IN IN IN IN IN IN HEAD IN IN IN IN IN IN
SCREAMING HEADLINES SCEAMING HEADLINE SCREAMING HEADLINES SCREAMING
HEADLINES IN EYES MY SCREAMING MY EYES SCREAMING IN HY HEADLINES MY SCREAMING EYES
MY SCREAMING MY SCREAMING SCREAMING MY MY MY HEADLINES MY HEADLINES EYES EYES
MY EYES MY EYES MY EYES MY EYES MY EYES MY EYES
HEAD EYES HEAD EYES LINES EYE
MY IN SCREAMING MY SCREAMING LINES IN MY HEAD
MY EYES MY EYES MY EYES
SCREAMING SCREAMING SCREAMING SCREAMING SCREAMING SCREAMING SCREAMING
SCREAMING
HEADLINES IN HEADLINES LINES HEADLINES MY
LINES MY EYES MY SCREAMING EYES
IN MY EYES
MY EYES SCREAMING
LINES SCREAMING IN MY HEAD
HEAD SCREMAING IN MY LINES
EYE LINES SCREAMING IN HEAD MY
LINES LINES LINES LINES LINES LINES LINES LINES
SCREAMING SCREAMING SCREAMING
HEAD
SCREAMING
IN
HEAD
SCREAMING
SCREAMING
HEADLINES
SCREAMING
lines
IN
MY
EYES
SCREAMING
SCREAMING
SCREAMING
SCREAMING

KSENIJA KOVACEVIC

BELGRADE, SERBIA

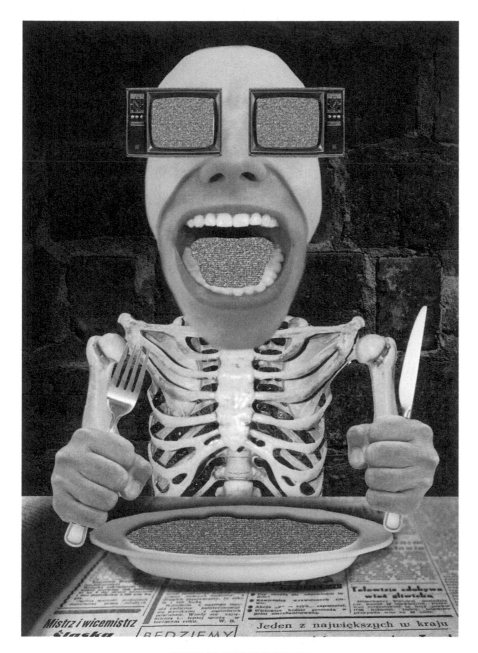

YOU'VE BEEN SERVED

Digital collage

GLOBAL RAINDROPS DRYING

Paper, 4 x 4 inches

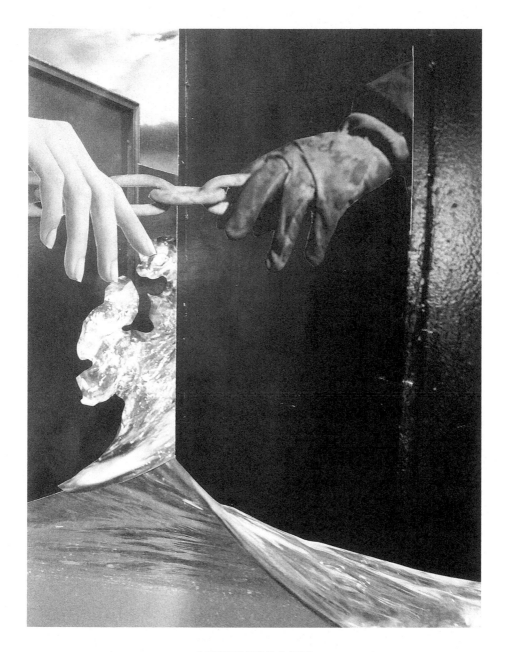

MAYBE TOO LATE

Collage, 21 x 29 cm

MARK BLICKLEY & AMY BASSIN

LONG ISLAND CITY, NEW YORK

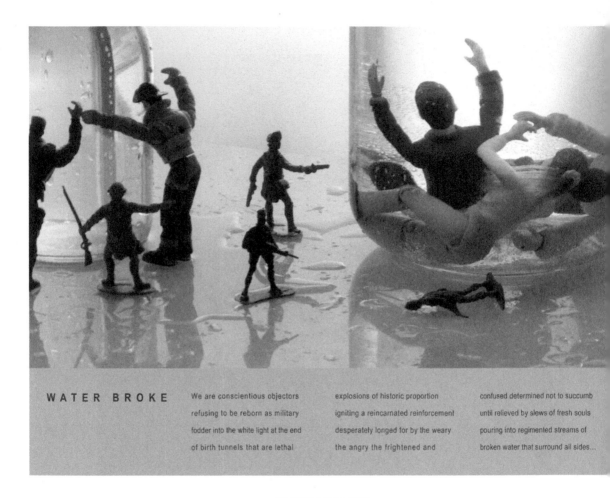

WATER BROKE We are conscientious objectors refusing to be reborn as military fodder into the white light at the end of birth tunnels that are lethal explosions of historic proportion igniting a reincarnated reinforcement desperately longed for by the weary the angry the frightened and confused determined not to succumb until relieved by slews of fresh souls pouring into regimented streams of broken water that surround all sides...

WATER BROKE

Text Based Photograph

"Dada talks with you, it is everything,
religions, can be neither victory

DAVID ISHAYA OSU

MINNA, NIGERIA

IT MEANS

as buttercups / we
　　burn / taking water, all
　　　　through the orbits—we don't
　　　　divide the red sea, we
　　　　　　close our eyes &
　　　　　　　　open our songbooks &
　　　　　　　　　　distance—it is
　　　　　　　　a forest, this
　　　　　　　　　　　colour: he hates
　　　　　　　　　　　　to know that the queen
　　　　　　　　　　　　　　owns the sky / that
　　　　　　　　　　　　　　soon a bird
will　　　　　　　　　　　　　　bring
him a
a red star, a ballot: it
　　means that at
　　　　the supper, we
　　　　　　will unbutton the lilac
　　　　　　　robe—it flies
　　　　　　through the clock
　　　　　　　　& through the call of
　　　　　　a sycamore

it includes everything, it belongs to all
nor defeat, it lives in space and not in time."
　　　　　　　　　　　　—Francis Picabia

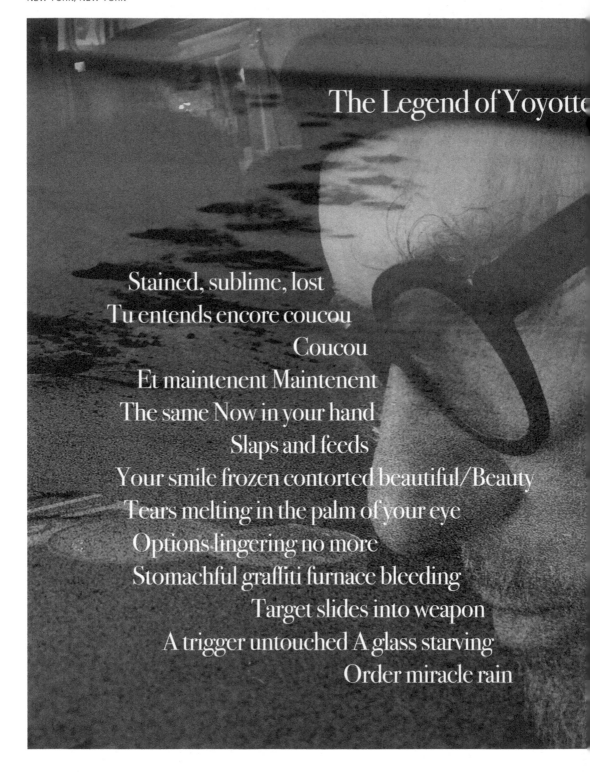

BOB HOLMAN & SOPHIE MALLERET

NEW YORK, NEW YORK

The Legend of Yoyotte

Stained, sublime, lost
Tu entends encore coucou
Coucou
Et maintenent Maintenent
The same Now in your hand
Slaps and feeds
Your smile frozen contorted beautiful/Beauty
Tears melting in the palm of your eye
Options lingering no more
Stomachful graffiti furnace bleeding
Target slides into weapon
A trigger untouched A glass starving
Order miracle rain

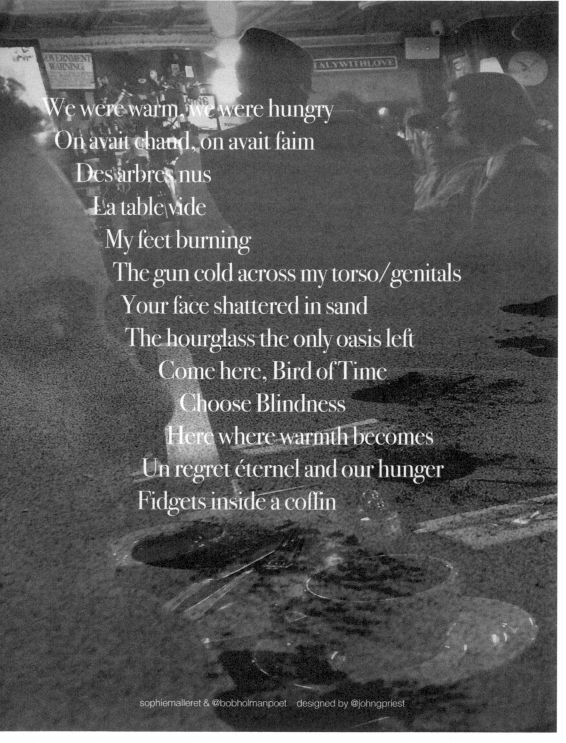

We were warm, we were hungry
On avait chaud, on avait faim
Des arbres nus
La table vide
My feet burning
The gun cold across my torso/genitals
Your face shattered in sand
The hourglass the only oasis left
Come here, Bird of Time
Choose Blindness
Here where warmth becomes
Un regret éternel and our hunger
Fidgets inside a coffin

sophiemalleret & @bobholmanpoet designed by @johngpriest

THE LEGEND OF YOYOTE

Photo collage

YURIY TARNAWSKY

WHITE PLAINS, NEW YORK

RED DOVE

How warm it used to feel
in the nests
woven from endless
gray borders,
how comfortable
the roots of its wings
used to rest
under the fingernails
chewed off clean
by the edgy
barbed wire,
and then came
these kisses,
raised high
like placards,
and they have scared it
away.

They have scared away
this red dove
with its eyes
and beak
of lead!

Where
did it fly to?
—There
where destroyers
run in streams
from the rheumy
eyes
of the ocean.

Why
did it fly away?
—To wake up
tiny black crosses
in the frogs' eggs
of maps.

Why, oh why
did it fly away?
—To make itself
a nest
out of long stalks
of pus
in the thinnest faces
of the yellowest
children.

And now no one
will be able
to scare it
away!

BARTOLOMÉ FERRANDO

LA ELIANA, SPAIN

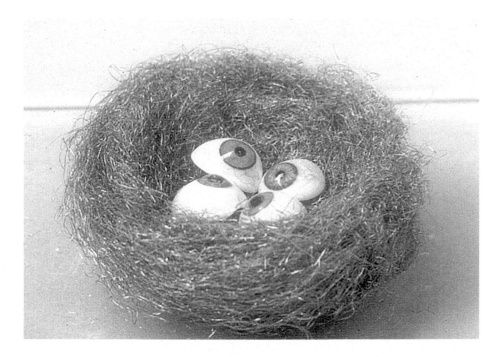

NIDO (NEST)

Crystal eyes + metalic thread, 12 x 4'5 x 12 cm

FRANCO GÖTTE
BROOKLYN, NEW YORK

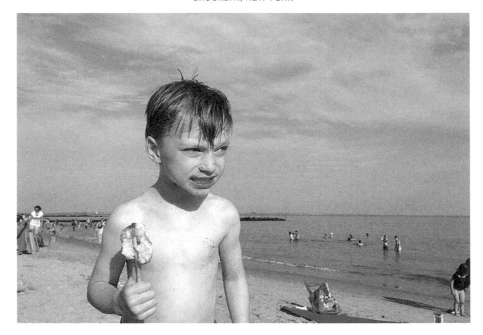

WARMONGER

Photograph

MARTINA SALISBURY
BROOKLYN, NEW YORK

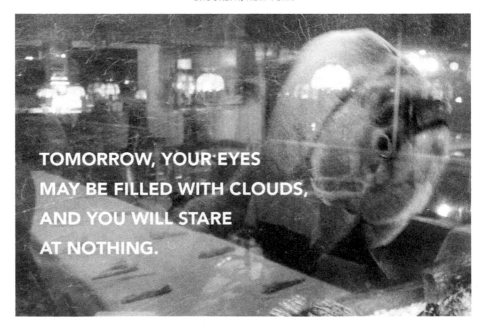

TOMORROW, YOUR EYES
MAY BE FILLED WITH CLOUDS,
AND YOU WILL STARE
AT NOTHING.

STARE AT NOTHING

Photograph / Text

HENRIK AESHNA

PARIS, FRANCE

AND WHAT IF THEY ARRESTED & DEPORTED ALL THE MONARCH BUTTERFLIES ??????????????

SCHIZOPOP MANIFESTO

Poster art

JOEL HUBAUT

PARIS, FRANCE

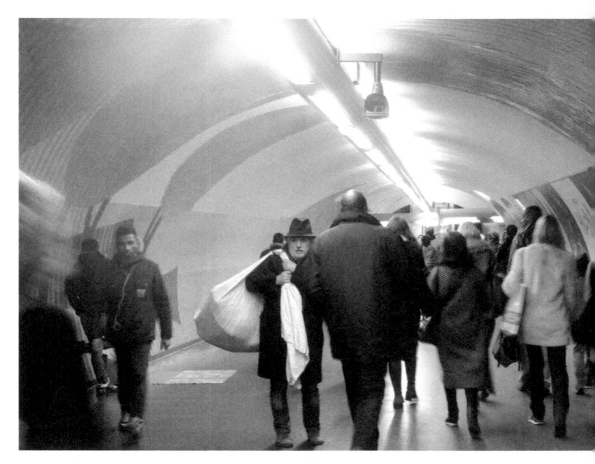

MIGRATION

Photograph of the artist by Frederic Acquaviva

"It has never been my object to record my dreams, just the determination to realize them." —Man Ray

DAVID BARNES

PARIS, FRANCE

INTERESTING TIMES
FOR GENERATION ZED

These are interesting times for generation Zed
Descending to the Underground
You pick up what is said
There's a tension in the news today
That'll tear your nerves to shreds
As the suicides all take their seats
Seven bullets to the head

These are interesting times for generation Zed
The skies are full of aeroplanes
Screaming overhead
Scattering plutonium
More poisonous than lead
I know they're bombing someone
Terrorists, they said

These are interesting times for generation Zed
This spaceship Earth is ticking
Like a timebomb in my head
We're dictated to by autocue
And we take it all as read
We're eating glass and anthrax
Like we eat the lies we're fed

These are interesting times for generation Zed
Four horsemen were approaching
And this is what they said:
"It only costs indifference
So despair and turn your head
Distract yourself with toys and games
While the sun sets bloody red
And if what you see offends you,
Put out your eyes instead."

These are interesting times for generation Zed
So dream on televisionaries
And follow where you're led
Stuff yourself with prozac
Til you can't climb out of bed
Buy yourself an alibi
And join the walking dead

(According to urban legend "May you live in interesting times" is an ancient curse. This poem was written after the 2005 London bombs and the killing of Jean Charles de Menezes. Mistaken for a terrorist suspect he was restrained by police who then shot him seven times in the head. After 9/11 Hunter S. Thompson wrote that the next generation of Americans will be the first in history to earn less than their parents . . . he called them generation Z.)

POUL WEILE

BERLIN, GERMANY

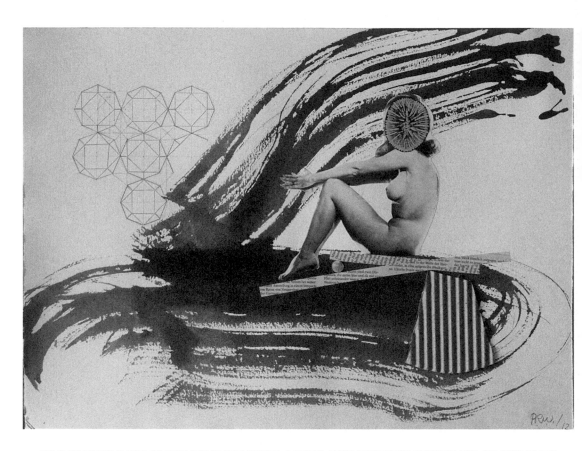

IN DIE ZUKUNFT OHNE HINDERNISSE / INTO THE FUTURE WITHOUT OBSTACLES

Misc. technic on hahnemühle paper 39 x 54 cm

BIG WAVE

Fayence, craquelée; 45 x 20 x 25 cm

PHILIP MEERSMAN
BRUSSELS, BELGIUM

MARE NOSTRUM

I present you on a tray
— the head of Jochanaan —
look into the lens, mirror of the soul

I twitter my lesser thoughts
— stream of conscience —
facts, figures, graphs to left-swipe
in a thumbs-up trance
my status is my creed

I walk on water
— I could sail or split it —
the buoyancy of toddlers
as sirens guard the graveyards

I fill the moon with the blood of the damned
— reflection in the salted sea —
the call of carcasses in cooling vans stranded
alongside the yellow big road
pickled dreams

I write what not wants to be read
— building blocks of Babel —
cries of impotence, studies filled with numbers,
reports with values
scanning destruction

I gave you fire to burn away the image
Water to deepen the distance

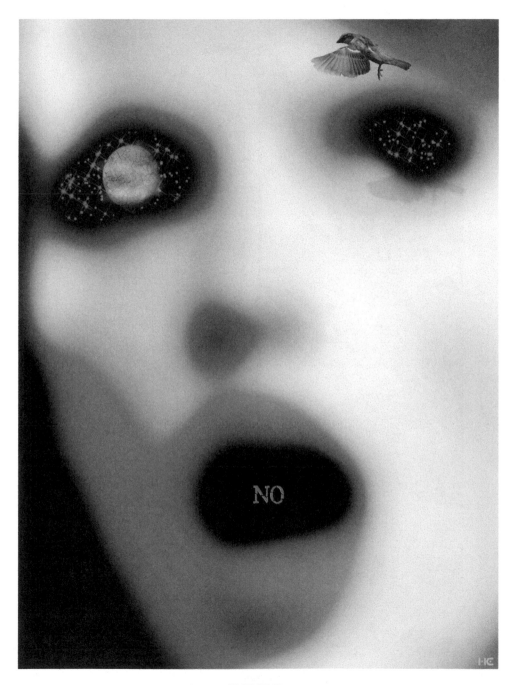

THE END.

Digital collage

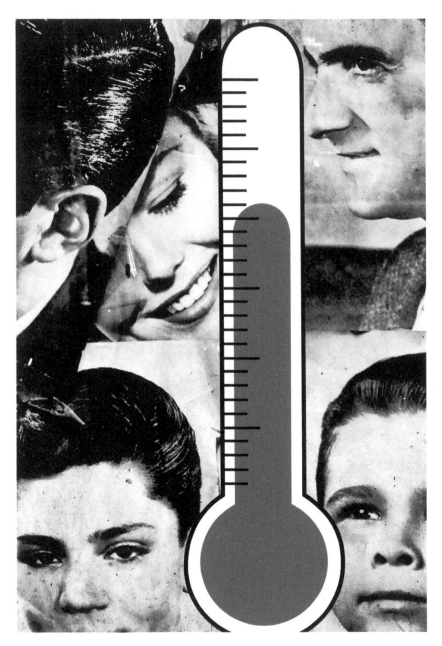

RISING

Digital image—slide owned by John S. Paul, with appropriation

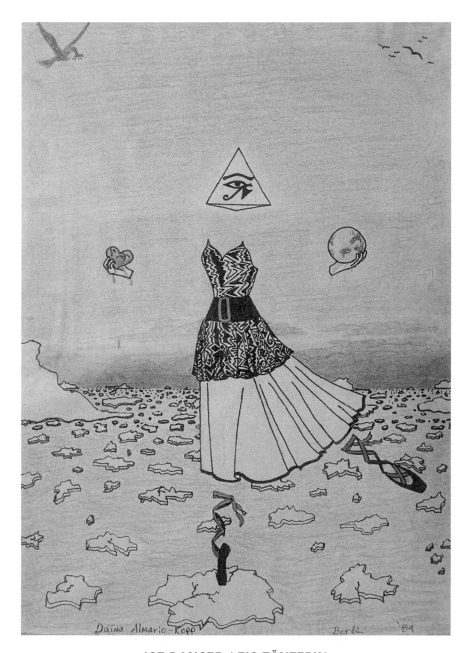

ICE DANCER / EIS TÄNZERIN

Fountain pen, colored pencil, metallic pen

PAUL Y.J. KIM

FRESH MEADOWS, NEW YORK

JUST AN ORDINARY DATE IN AN ORDINARY WORLD

Jeremey Riddle was walking down the street to pick up his lovely date with the girl of his dreams, Daisy Lowell. It was a tepid January evening where the sun was gently shining in the sky, not too warm. On his way to her apartment building he happened to pass by an electronics store where a flat screen television was turned on for display. An anchor woman was reporting the news and he stood there for a moment to listen.

"Violence escalates as ISIS establishes their radical caliphate absolute in the Middle East and moves southwards where Boko Haram has seized most of northern Africa and turned it into their own self-proclaimed country. In Russia President Putin denies access for anyone to enter or leave and has put the country under lockdown. In Asia, China, Japan, and South Korea agree to an alliance to battle the radical terrorist threats inspired by recent events.

"In other news, prices have risen once more and a pack of bacon will now cost you at least ten dollars, that's double the price from ten years ago. Infuriated citizens are on the streets everywhere protesting for change. No one is sure if it's possible at the moment. . . . "

He walked away because when he checked his watch it was five minutes past when their date was supposed to have started. He started to run past the busy avenues and turned sharply to a quieter street and at the end he saw Daisy wearing a light blue dress with a white cardigan made of wool.

"Isn't it a little too warm for wool?" asked Jeremey as he took deep breaths.

"No, and if it gets a little too warm I'll just take it off," said Daisy as she gave him a little smirk and took his arm. "Anyways, did you hear about how they're kicking out all the current homeless people out of the country? It's horrible!"

"You think that's horrible, a journalist colleague of mine told me by next year Hawaii will be submerged underwater completely."

"Aw boo, we won't ever get to visit Hawaii then!" she said as she pouted.

All he could do was smile. He hoped the world wasn't ending any time soon.

MARK KOSTABI

ROME, ITALY

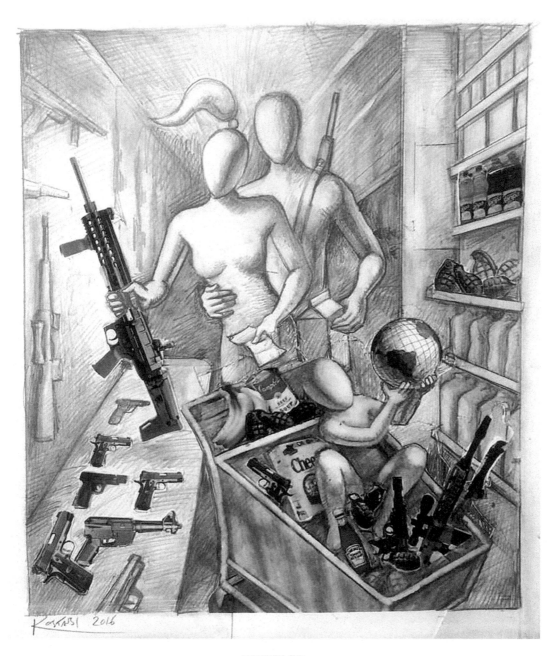

UNTITLED

Drawing / collage

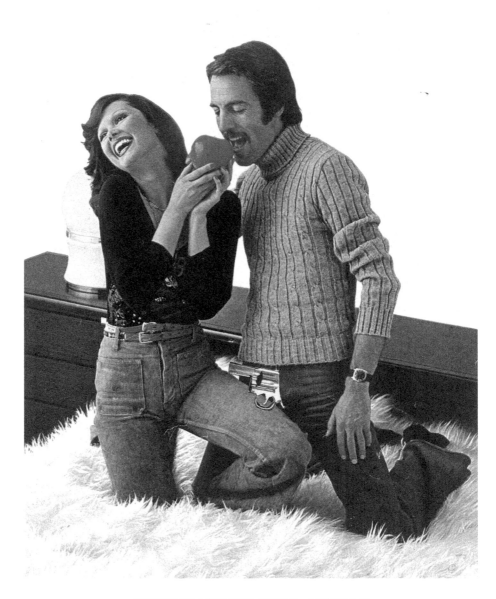

DON'T BLAME THE APPLE, ASSHOLE

Collage

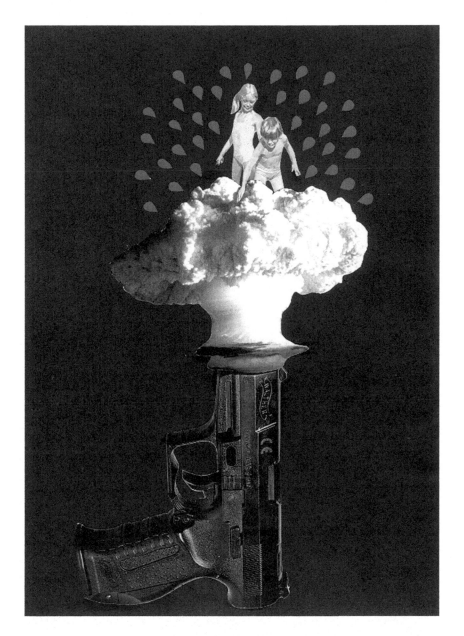

UNTITLED

Collage on card; A4

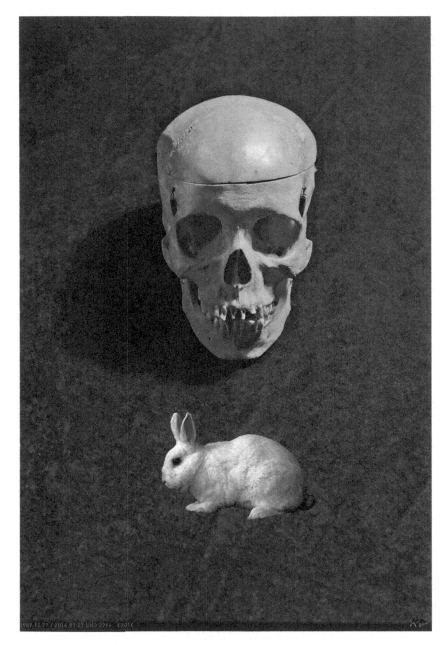

HERE COMES THE BLIMP!

Photograph

JOHANN REIßER

BERLIN, GERMANY

Running

Order

73-15

„It just keeps

going and

going and

going..."[1]

The continuously beating pack of bunnies bursting with energy

surges again and again to the humdrum push push tunes of hunger

for more drummers steadily fusing increasingly using the freely

floating looms of their even tunes to rub their fluffy busy

body beat into sleepy eyes right up to the empire of the tooth

fairy queen right up to the ultimate projection screen looping

endlessly bunny reasons with warm front seasons for further packs

of bunnies never slowing but keep on going and going and going

[1] Slogan of the Duracell Bunny, which promotes Duracell batteries since 1973. Duracell is part of the Gillette Company. The multinational company is headquartered in Boston and produces apart from batteries shavers (trade name: Gillette), electrical appliances (trade name: Braun), and dental care products (trade name: Oral-B). 1973 also saw the decoupling of the dollar from gold standard, which marked the beginning of floating exchange rates which pushed currency speculation ahead. Socialist Allende government in Chile also was overthrown in 1973. The following Pinochet government was a model test for neoliberalism. Friedrich A. v. Hayek, one of the masterminds of neo-liberalism, was awarded the Nobel Prize in Economic Sciences in 1974.

KOFI FORSON

NEW YORK, NEW YORK

TOMORROW'S HYBRID, YESTERDAY'S TROUBLE

Among Wall Street mongers, rotund participants of fast food machinery
Rest your eyes on ever-growing nomads, citizens desperate, determined
Diseased, carbonic air, conditions from threatening heat, oncoming cold
Desireless, interspersed between airport terminals, neighborhood parks

These are your displaced lawyers, fashion designers, substance abusers
Comas can, often does bring you closer to death, car crash or beat down
Hordes gathered over heating vents, under walk ways, public bathrooms
Modern day horror show, incapacitated, hammered by blow of wind, fists

Tumultuous sight, ignite if in a dream, commonality, such thing as normalcy
A house holds more than its people, memories are manufactured for eternity
Pale reflection in the mirror, unshaven face, sunken eyelids, leathery texture
This portrait colorless, muddied grey yearns a douse of water, so plain, so free

Beaches polluted, populated, whales, fishes, marine life washed up on shore
Purity of sand, our safe grounds tormented, syringes, knives, uninhabitable land
Some escape to their vacation homes, Martha's Vineyard, villas in Santa Barbara
This is America, Silicon Valley exists here, so do The Hamptons, Hollywood Hills

In this city where other cities meet, we are a country to tourists, dignitaries
Hotels squared for catered events; peopled-circles sit at tables with cuisine
Places near not far, beggars humble themselves, arms outstretched, dour
Circumstances unbeknown, written on cardboards, explained as a confession

Amendable homes, more than just shelter, but placement for an ordinary life
Ovens, beds, four-walled sacrifice, not the pantry, church basements, civilization
A world awaits, welcomes us redefined, a mind made healthy, enduring time
A world as this, a heart's beat away, fire, even death, should we ever forget

CHRISTIAN GEORGESCU

SUNNYSIDE, NEW YORK

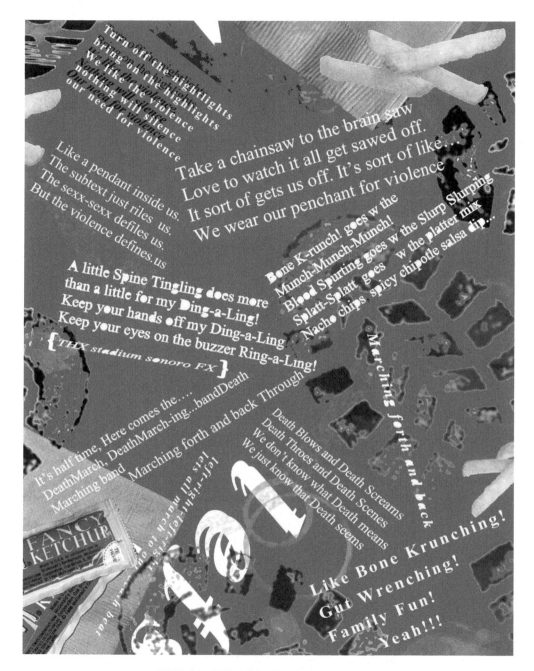

THE S'AINT COMES MARCHING IN

Jpeg

JASON ABDELHADI

OTTAWA, CANADA

DONATED GOODS DISTRIBUTION PLAN
FOR INTOXICATED IMMIGRANTS

THANKS TO THE PEOPLE OF THE AMERICAS FOR THEIR GENEROSITY, REALLY

THE JOINT MILITARY POWERS SUGGEST WE STRAP YOUR DONATED GOODS TO THE BACK OF A CAMEL, ALONG WITH A FLAG BEARING THE WORDS "HOPE. PERSERVERANCE. TOMATOES." IN 23 LANGUAGES. IN TOTAL WE RECEIVED:

BREAKFAST - 73 units: shredded wheat/shrapnel breakfast cereal overstock.

JONESING - 6000 units: tobacco carton miniature portrait lockets, containing a picture of a cigarette and a lock of tobacconist's hair.

FRIENDLY RIDE - 4 units: transportation vehicles with angry looking "face."

MEDICS - 580 units: scorpions with first-aid training (self-curing).

ORIENTATION - 1 unit: map of the Middle East (have a quick look and pass it around).

SPECIE - 322 units: coins from the ancient near-east AKA refugee tokens for entry into European history.

LUNCH - 68 units: pulled pork sandwiches.

GRAPHITE - 4500 units: half-pencils for the jotting down of thank you notes.

GINGIVITIS - 10,000 units: powdered metal rust tooth paste.

PRODUCT - 12 units: cleanser, all purpose, flour, all purpose, substances, all for a purpose, steel filings.

CANNED GOODS - 15,000 units: chickpeas for their "local" dishes.

TEA - 2.3 million units: no sweetener.

MITTENS - 300 units: stapled together from leaves, sticks, discarded cotton and leather.

DINNER - 53 units: rice, carrots, roaches, potatoes, sauces, roaches.

BLANKETS - .05 units: for warmth in the Middle East, not a big issue given the Sun.

THANKS AGAIN PEOPLE OF AMERICAS

THANKS AGAIN FOR GIVING BACK

**—Generalissimos United Charitable Organization
for the Promulgation of Dadas in Diapers**

CRISIS

Photo; 21x28 cm

FAUSTO GROSSI

BILBAO, SPAIN

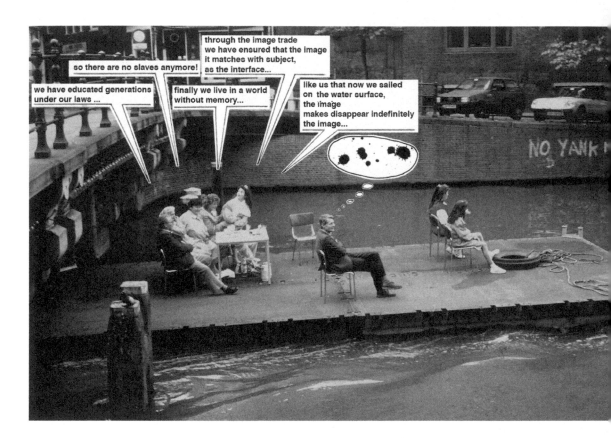

100 YEARS AFTER DADA

Infographic

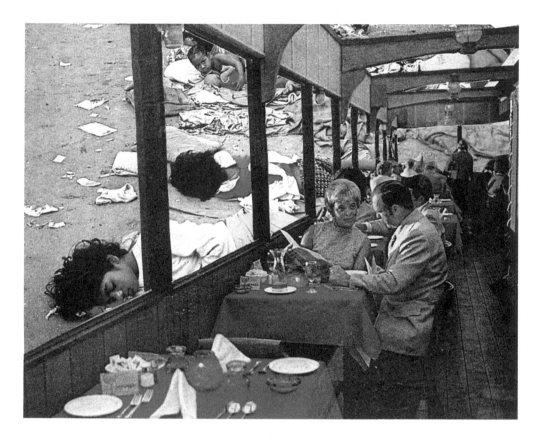

WHAT TO HAVE TO EAT, SO MUCH CHOICE !!

Analogue collage, 30 x 20 cm

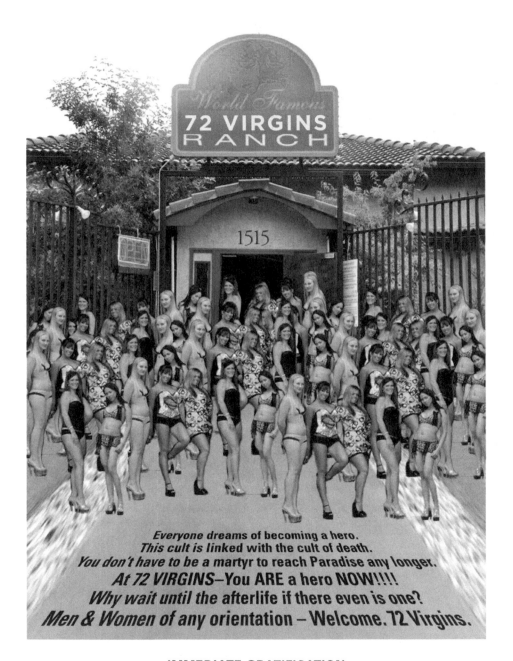

IMMEDIATE GRATIFICATION

Digital collage

LINDA J. ALBERTANO

VENICE, CALIFORNIA

DELUXE DAMAGE

The CEO of a luxury death-machine sits
sunny-side-up
on a luxury lily-pad in a luxury lily-pond.

He's green and preening
(knee-deep, knee-deep). Watching
icecaps melt in his premium whisky. Watching
polar bears dance on the point of a pin.

He's warm.
And sweaty. Fire, flood and famine
fill his oily black planet. He's hungry.

An unwary human towing wife and kiddies
suddenly snags his attention.
Thip! Thip! Thip, thip, thip! Five quick flicks
of his flypaper tongue.
Collateral damage complete.

Happy hunting, Warmhunger. You'll bomb us all
back to the stone age.

Soon.

JOHN BOWMAN

NEW YORK, NEW YORK

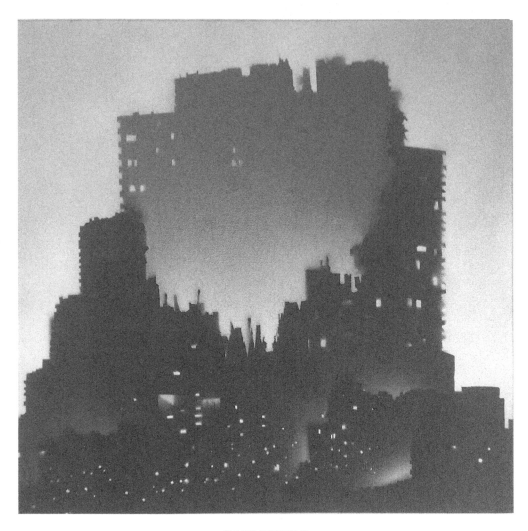

CAULDRON 3

Acrylic and enamel on canvas; 24 x 24 inches

KAT GEORGES

NEW YORK, NEW YORK

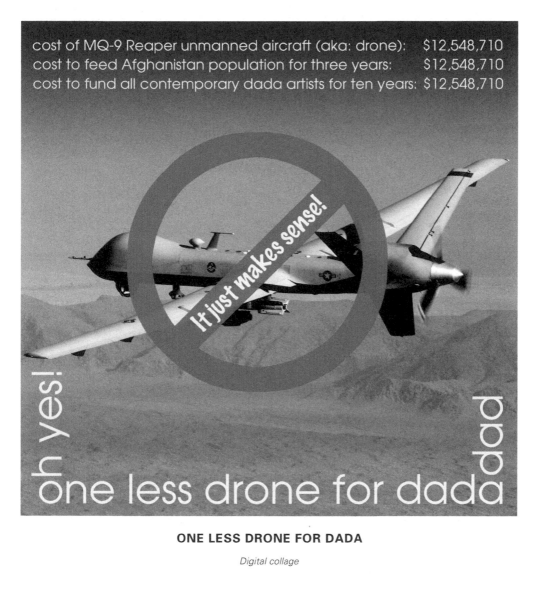

ONE LESS DRONE FOR DADA

Digital collage

S. A. GRIFFIN

LOS ANGELES, CALIFORNIA

PRESIDENTIAL CANDIDATE UPSIDE DOWN CAKE

15 sticks bloviating candidate

2/3 cup clueless nuts

9 slices (14-oz can) sound bites drained of any intelligence

9 slices Super PAC supporters

1 1/3 cups finely sifted all-purpose bullshit

1 cup granulated sexism

3 heaping spoonfuls of semi-automatic gunfire

1 cup racism

3/4 cup sour milk

1/4 cup spilt milk

2 tablespoons contrived controversy

a pinch of fascism

1. Preheat campaign to 451°F. Melt bloviating candidate in their own juices. Add racism liberally, coat in all-purpose bullshit. Sprinkle granulated sexism evenly over all. Arrange candidate and Super PAC slices; lay it on thick.

2. Save your nuts and hold the gunfire. In media mixing bowl beat remaining ingredients with news editorial on high speed scraping the bottom constantly. Stir needlessly. Pour over candidate/supporter slices. Don't forget to add that pinch of fascism!

3. Bake for months on end or until gerrymandered vote inserted into center comes out clean. Remove from campaign and immediately place non-stick sound bites over cooked heads. Turn upside down. Let the result sit a few sessions so the gooey mixture can drizzle over confused mess. Pepper with semi-automatic gunfire then garnish with clueless nuts. Keep warm in global oven. A perennial party favorite and guaranteed winner every time!

Serves millions.

JOANIE HIEGER FRITZ ZOSIKE

NEW YORK, NEW YORK

HUNGRY WORLD

Text and collage/electronic

"New things had to be made out of fragments." —Kurt Schwitters

MIKE M. MOLLETT

LOS ANGELES, CALIFORNIA

STRAWS FOR A VAMPIRE

The newspaper sucks my eyes secretly toasty
leaves me without a birthday without a tree
leaves me on a rope in a daze indifferent

myself off to work where the guru is gone
off my hinges cared for with teeth

I'm off the mediators schedule now too.
the newspaper walks up to me and burps
the newspaper lights out of the bank calling the president a prick
I wonder how much the newspaper really knows about heads of state
I wonder if human beings still work for the newspaper

yesterday's newspaper wasn't delivered into my driveway
it was on-line bannered up the wahzoo with slashing pixels
germs of cacophony also sat at that table & spoke to me with syllables of discord
in the corner a good-thing headline was lonely nailed to boards in the freezer
where the corn is rotting, the ladles & vents rusting, the gravy sour

in the newspaper the lines of knowledge are rained upon regularly
& flushed into the sewers
the weather is quite dependable there
ac & heat regularized on schedule out of mind

whether the public opinion polls are bastards or not makes no
difference to the vultures in the viral soup / chopped up and sautéed
the loss of limbs surely adds to unique piquant ambiguity
I find myself there too / often in this newspaper

angels are really demons of disguise in this bleeding media
a sucking state of world affairs working strange
osteoporosis in a nutshell gotta go

—from Raw Cuts, a poetic manifesto

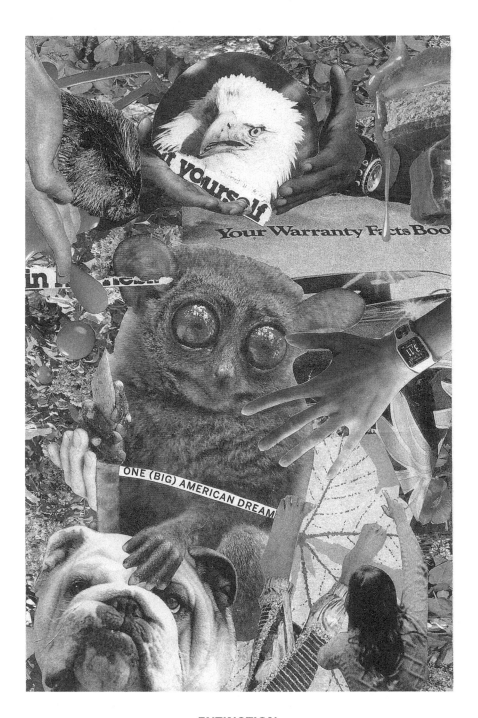

EXTINCTION

Collage on paper; 4 x 8 inches

JÓZSEF BÍRÓ

BUDAPEST, HUNGARY

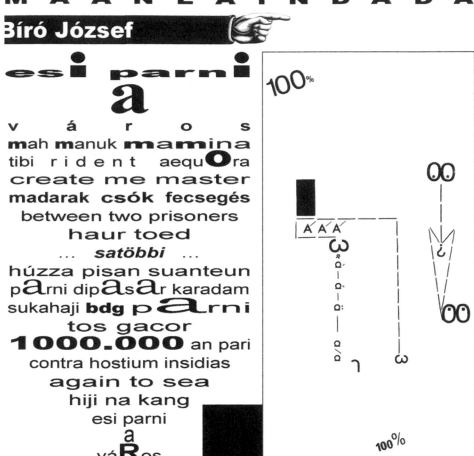

DADA

Jpeg

DIALÉTICA DA FOME

A4

JAN MICHAEL ALEJANDRO

LOS ANGELES, CALIFORNIA

SOME THINGS TAKE A LIFETIME TO GET RIGHT

Walking up hill on the broken pavement
I know to look down
I know to step over the root damaged cracks
The surroundings are distracting
The memories are suspect
The lines are yet to be written
Crossed
Symmetrical

Some things take a lifetime to get right

Sometimes you sell
Sometimes you get sold
Hurt, get hurt
Leaving the tonearm on the skipping record
Johnny laughs, Johnny cries
Hear the National Anthem then sign off
Remembering the white noise
Passing through a long corridor of clichés

Some things take a lifetime to get right

Struggle to sort out the positive
and the negative particulate matter,
because life matters in relative ways
Can I sit in that beautiful chair?
Should I swim in that beautiful sea?
I'm here now . . .
Stop relying on the cheat sheet
Cut up the words in the sentence
Rearrange them
Take in the real beauty
Add it all up
Nothing lasts forever

Some things take a lifetime to get right

(Dedicated to my former boss, David Bowie
(January 8, 1947 – January 10, 2016) . . . RIP)

LYNETTE CLENNELL

SUMMERSTRAND, SOUTH AFRICA

7 BILLION

Paper collage—hand cut/torn, glue

TEMPLE

Mixed media assemblage, 11 x 13 x 8 inches

KATHLEEN REICHELT

LANSDOWNE, CANADA

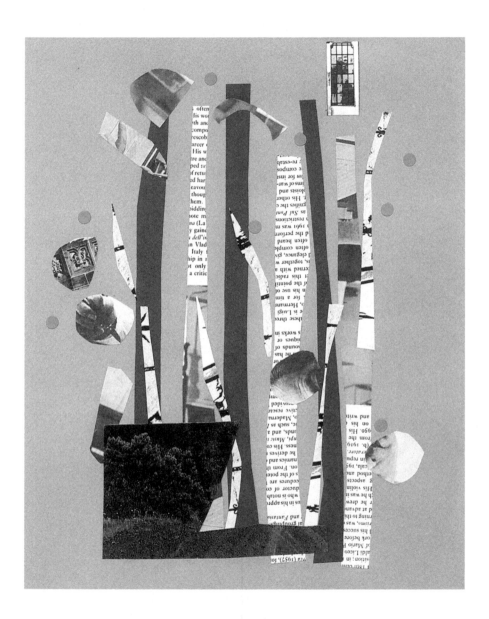

WHERE IT GROWS

Paper collage, 5 x 4 inches

REBECCA GRIFFIN

BELCHERTOWN, MASSACHUSETTS

AUDI VS. ME

Audi	**Me**
Audi luxury	Netflix in bed
Careers	Tupperware with lids, various
2017 R8	Three new turtlenecks
Starting at $53,100	Turkey pastrami sandwich with chips
Powerful	A hairdryer
Seductive lines will draw you in	A heating pad (for feet)
Taking performance to the extreme	Pajama set (fleece)
Audi duffel bag (price $49.00)	A bowl of pasta with cheese (parm.)
Audi hard sided global carry-on by Victorinox (price $329.00)	A tub of movie popcorn with butter
Audi RB custom luggage set (price $7,400.00)	A tub of movie popcorn with extra butter

RICHARD STONE

SAN FRANCISCO, CALIFORNIA

```
D U C H A M P       R E A D Y M A D E
O N R E R A E       I N S O E A U E V
W D A D E I R       S D   M O K S C I
N E Z O   N P       Q E   I M E T I D
  R Y N   L E       U A   N E   E S E
      I   Y T       E V   E N   R I N
      S     R         O     E   E O T
      T     A         R     R     N
      S     T         S     I
            I         N
            N         G
            G
```

```
M E L T S     A W A Y     I N    D A L I     T I M E
O V A A I     S H S E     N O    E R E N     R N A V
R E Y S M     S E S O     D I    S G T T     U C L I
E R M K P     E N U M     I C    I U T E     T I I D
O Y A S L     S   M A     C A    R M I R     H T C E
V D N   I     S   E N     A T    E E N E     S E I N
E A     F     M   D       T E    D N G S     E   O C
R Y     I     E           E S      T   T     E   U E
        E     N           S        S   E     K   S
        D     T                        D     E
              S                              R
                                             S
```

```
D A D A     F O O T S     T H E     B I L L
I N R N     R V R O E     H E V     R T Y O
L A A G     O U B   A     E R O     I   I W
I R I S     M L S   L     M L       N   N
G C N T     A             E U       G   G
E H I       T             T T       I
N I N       I             I I       N
T S G       N             C N       G
S T         G             O G
                          N
```

SEDŌKA

Jpeg, 4 × 5 inches

JOEL ALLEGRETTI
FORT LEE, NEW JERSEY

RITUAL PIECE IN D MAJOR

For Solo Acoustic Guitar

To be played daily at 5:30 a.m.until no one knows the indignity and material burden of deprivation

In a hopeful manner Joel Allegretti

COMPOSER'S NOTE: The principal characteristic of Ritual Piece in D Major is the fact that, as a composition written expressly for unaccompanied acoustic guitar, it is unplayable. The work consists of a whole note held for thirty-two measures. No acoustic guitar can sustain a tone that long.

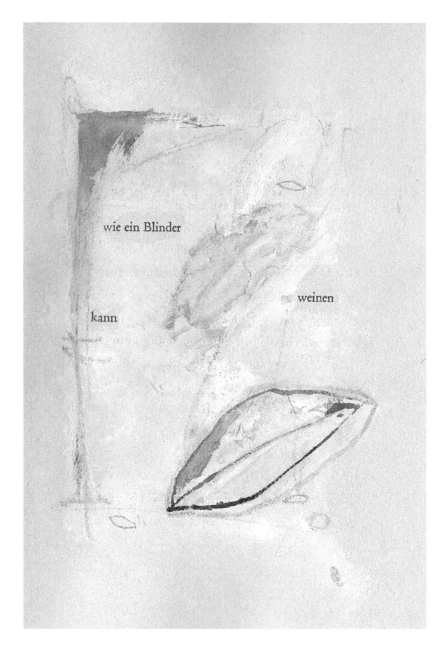

PAGE FROM UNIQUE ARTIST'S BOOK:
RAINER MARIA RILKE, REQUIEM, 2012

Mixed media; 7.25 x 4.75 inches

SUSAN KEISER

OSSINING, NEW YORK

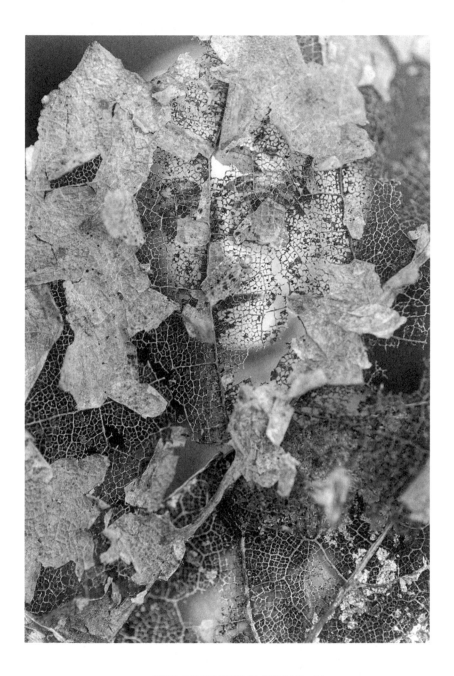

THE LAST WAVE BY NO. 44

Archival pigment print; 20.25 x 13 inches

LISA PANEPINTO

PITTSBURGH, PENNSYLVANIA

RAPTURE

anna stopped me on the road

below her house on the hill

she told me about the journey

drumming takes you on

the human skull is the most resonant drum

on earth the human voice coming from it

is powerful holy music

a wail came from her house

an orange bow in her black hair

she smiled danced as cars passed

i began to see visions

fasting in the sun

she whispered

the government's trying to kill us

with drugs & bad food

& chemical water

and i walked home singing

for the salmon

to make it past the dams

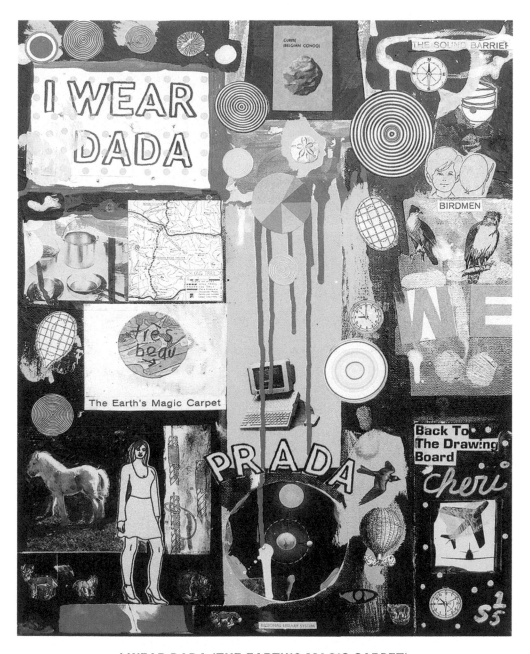

I WEAR DADA (THE EARTH'S MAGIC CARPET)

Paint and collage on canvas, 16 x 12 inches

ROXIE POWELL

COLUMBIA, MARYLAND

A PIECE OF DADA

So intimate

Embarrassed, I

Watched Juan Manuel Fangio

Reduce himself sufficient to

Dangle like a coupee doll

Down Sterling Moss's

Windscreen, a wide gape

Levered by the lassitude of

Certainty and why not truth,

For it extruded, the moment

Ugo Calise came out to sing, until

His pain overwhelmed the abutted duo.

You ask, "And you remember this? And my

Reply was to show you that they are both

Still lodged in my anal sphincter, still smiling,

Though now gone toothless.

LAURENT MARISSAL

TRILPORT, FRANCE

shook hands with
BEN VAUTIER — PAINTERMAN
shook hands with — *shook hands with*
GEORGE BRECHT — CLAUDE VIALLAT
shook hands with — *shook hands with*
ROBERT FILLIOU — RAOUL HAUSMAN
shook hands with — *shook hands with*
JOHN CAGE — EMMY HENNINGS
shook hands with — *shook hands with*
RAUSCHENBERG — HUGO BALL
shook hands with — *shook hands with*
DE KOONING — TRISTAN TZARA
shook hands with — *shook hands with*
JACKSON POLLOCK — FRANCIS PICABIA
shook hands with — *shook hands with*
ROBERT MOTHERWELL — CAMILLE PISSARRO
shook hands with — *shook hands with*
MARCEL DUCHAMP — PAUL CEZANNE
shook hands with — *shook hands with*
ERIK SATIE — NADAR
shook hands with — *shook hands with*
STEPHANE MALLARME — PIERRE KROPOTKINE
shook hands with — *shook hands with*
EDOUARD MANET — LOUISE MICHEL
shook hands with — *shook hands with*
CHARLES BAUDELAIRE — GUSTAVE COURBET
shook hands with — *shook hands with*
EUGÈNE DELACROIX — VICTOR HUGO
shook hands with — *shook hands with*
THEODORE GERICAULT — F.-J. TALMA
shook hands with — *shook hands with*
JACQUES LOUIS DAVID — A.-M. CHENIER
shook hands with — *shook hands with*
THOMAS PAINE — OLYMPE DE GOUGES
shook hands with — *shook hands with*
WILLIAM BLAKE — MARY WOLLSTONECRAFT
shook hands with

I make no difference between
a handshake and a poem.
Paul Celan.

And we will see the pertinence
of Crec proverb, saying the
nunc is to begin the story.

NADA IN (3), SHAKEHANDADA

Offset impression

JANET HAMILL

MIDDLETOWN, NEW YORK

THE GARDEN AND THE TOMB*

I know a garden of flowers – orchids of far exotic colors, like tiger lilies or pondering amaranths. Flowers. Flowers of fire. Flowers whereof there is no symbol in heaven or hell. Flowers lovely and marvelous. Enchanted flowers in the alternative garden of Satan. Perfect and immortal. Fierce and splendid. Bright and cold as crystal. Having no likeness in any world. Multiform flowers. Folded petals of triple suns. Pale petals of Paradise. Flowers as beautiful as crimson seraphim or the golden snow of the sun.

Alas! In the heart embowered with vine and the gleam of marble, flowers breathe like children corrupted – crawling essences of their abiding place. The garden is a tomb of blossoms where the careless, incurious sun still slumbers, torn from end to end. A tomb so trellised, the light reveals a ghastly scrutiny. But in the night, perfumes are as faint as serpents trailing the fetor and phosphorescence of the moon.

(Cut up of "The Garden and the Tomb" by Clark Ashton Smith)

"What art is, in reality, is this missing link, not the links which exist. It's not what you see that is art; art is the gap."
—Marcel Duchamp

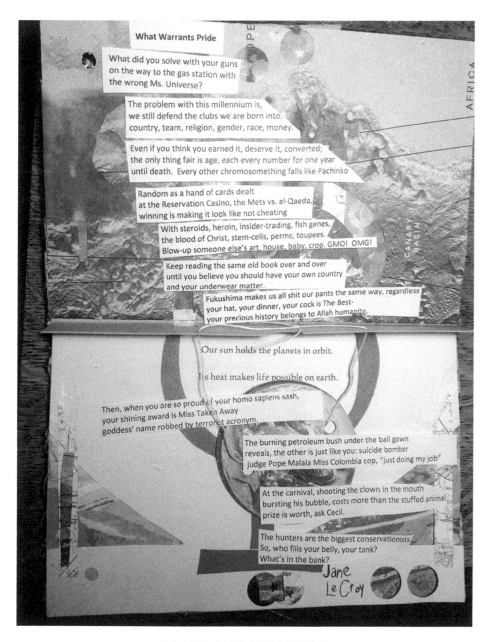

WHAT WARRANTS PRIDE

Photo collage

GLEN CALLEJA

NAXXAR, MALTA

HUNGRY DOG

Man lets a dog lick his hand, enjoys it.

This wetness is unfamiliar but pleasant.

Man whispers to the dog in a kind exchange

because he has enough language and imagination.

He doesn't do anything else.

GREG BACHAR

SEATTLE, WASHINGTON

WRITTEN BY ONE OF THE CHORUS

I walked out of the desert

with a brick and a chicken.

In the shade of my oasis palm

I brained the bird and built

a small house of stone.

There was honey in the cheese

and doubt in the foundation.

Souls never early or late,

we ate well before sleeping

on my new stone floor.

HOPE KROLL

PASO ROBLES, CALIFORNIA

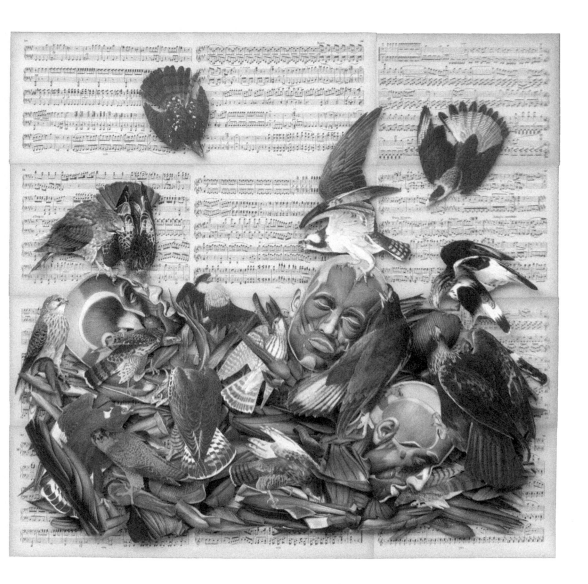

THE FLESH EATERS

Hand cut paper collage, 3D, 30 x 30 inches

PUMA PERL

NEW YORK, NEW YORK

DAYS OF FAITH

The survivors shuffle slowly into church
Prayers Up! they whisper as they enter
These are days of faith and no hope

Food lines wind around the block
Peanut butter's greasy
Bread is hard and stale

I used to smell like oranges
Or was it lemons?
It's hard to remember citrus
and roses and gasoline

Late at night I recall the smell
 of burning buildings
 and the smoky aftermath

Startled, I jump from my cot
Reach for something worth saving
 but the room is empty
Church bells ring throughout the night

MARK HOEFER

SAN DIEGO, CALIFORNIA

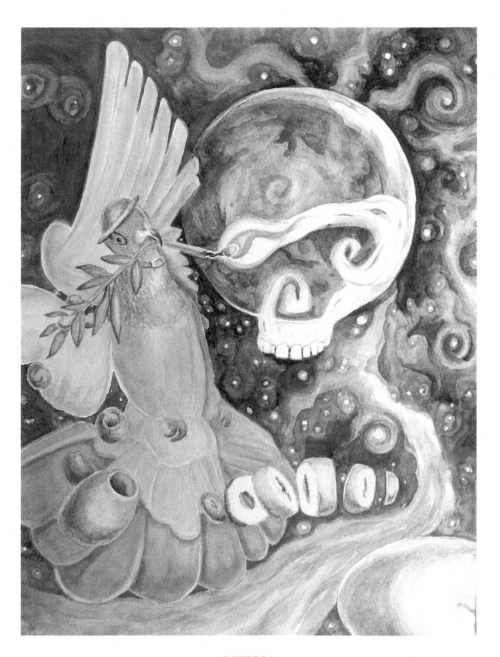

PITTED!

Watercolor, 12 x 16 inches

MUSSEL BEACH

Porcelain, mussel shells, wood, mushrooms, sand; 20 x 14 inches

NEW SUN, OLD LOVERS, STILL STRANGE

Color pencil and pens; a4 size paper ripped from visual diary

DUSTIN LUKE NELSON

ASTORIA, NEW YORK

from **IN THE OFFICE HOURS OF THE POLAR VORTEX**

Staff paper, digital scan, ink, coffee, 8.5 x 11 inches

RICHARD MODIANO

VENICE, CALIFORNIA

ANTHROPOCENE

Thank you Charles Lyell
you who distinguished between various layers of rock
determining the proportions of extinct and non-extinct fossils each contained—
~*cene*-Greek—*kainos*-recent

Miocene, *meios*—*few* of the fossils are recent
Pliocene, *pleios*—*more* of the fossils are recent
Pleistocene, *pleistos*—*most* of the fossils are recent
Anthropocene, *anthropos*, man, human being—humankind is the new geological force
 transforming the planet beyond recognition, chiefly by burning prodigious amounts of coal,
 oil, and natural gas

anthropogenic
Rapid melting of arctic sea ice
 reduction of the earth's albedo—

Melting of the frozen tundra in northern regions
 releasing methane (a much more potent greenhouse gas than
 carbon dioxide) trapped
beneath the surface, causing accelerated warming—

Growing ocean acidification (from past carbon absorption)
 carbon build-up in the atmosphere and enhanced warming—

Extinction of species due to changing climate zones
 leading to the collapse of ecosystems dependent on these species, and the death
 of still more
species—

 terminal crisis—a death of the whole anthropocene
 the period of human dominance of the planet

FORK BURKE

BIEL-BIENNE, SWITZERLAND

MONOCROP

Ancestor yourself against CUT Truth always sounds unbelievable to those holding

on with wrong story

Taken out of our food CUT soy confusion weed killer white flour 1910

communication

Not allowed to look back Need

Walking into separation Cutting

 A jar loosened by all the right hands

Listen to the ones who can barely say it

(down by the riverside) legal illegal legal illegal lynch n lunch

Cruelty let us celebrate ShapeShifter Housing

one large Pablo Neruda power – good Jimmy the underworld

Because after reading something you wrote you've never been to China

the poets are not defeated

Official without forward unknown history exclusion

Me on a sofa and ready to write last night I`ll be there I came into this world at the time of sperm

and dumb bureaucrats ironic food St Petersburg a third thing happened by itself

invent anything impossibility events happen

who told us things nearby a divine wind

you grasp anything enormous speak orgasm

sperm moves bird bite history deep inside honestly

the reader all the lights were off

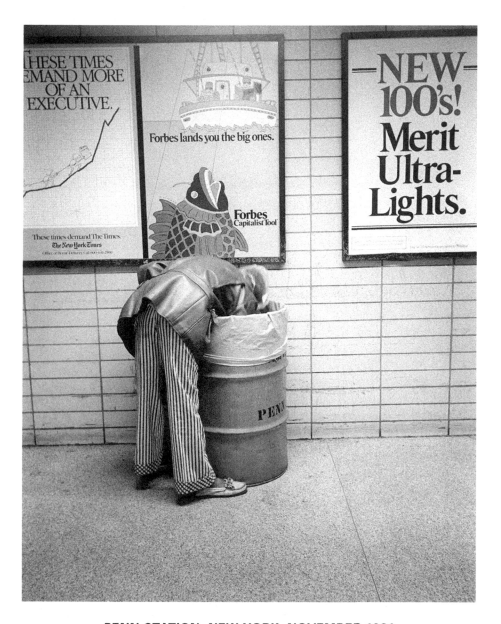

PENN STATION, NEW YORK, NOVEMBER 1981

Archival inkjet on Canson Baryta; 12 x 15 inches

A. D. WINANS

SAN FRANCISCO, CALIFORNIA

WAR/HUNGER

He sleeps in doorways
Or under the freeway
Refuses to go to a shelter
Not even when prodded
With the heavy weight
Of a beat cop's nightstick

Under threat of jail
He curls up in a fetal position
Tries to shut out memories
Of Vietnam
Nightmares that whirl inside
His head like helicopter blades
The alcohol the drugs the failed years
Gather like locusts inside
The frayed lining of his mind

Warrior poet troubadour
Pale spokesman of lost tribes
Masked as a homeless transient
Prophet of beauty and all its imperfections
Ravished by the streets
Left tired withered like
An unattended Kansas grain field

"A free spirit takes liberties

JOHN MAZZEI
SAN FRANCISCO, CALIFORNIA

"STAY HUNGRY, STAY FOOLISH" — STEVE JOBS

Photograph

even with liberty itself." —Francis Picabia

CRYPTID BIO CHAPTER 8

Digital collage

PAWEL PETASZ

ELBLAG, POLAND

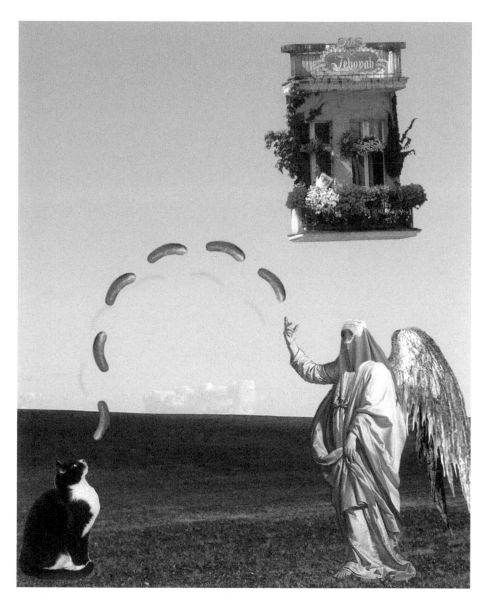

A GATELESS GATE

Digital collage

DUSKA VRHOVAC

BELGRADE, SERBIA

HUNGER

I always encouraged my hunger
cherished it to become greater
by giving it forbidden fruit
and those tiny, mysterious berries
of which you sleep even worse.
So with hunger
insomnia has woken up too
and these two blessed maledictions
they have made me pretty tough.
I began to hear forgotten games
lost melodies
unspoken words
and a talk from the other side.
I became a dash
a picture framed in counters
of its own shadow.
That hunger is so unappeasable now
as if I don't feel it anymore
and the night so infinite
that my insomnia seems like a long dream.

JÜRGEN TRAUTWEIN

SAN FRANCISCO, CALIFORNIA

BON APPETIT

Pen and ink on letter-size paper

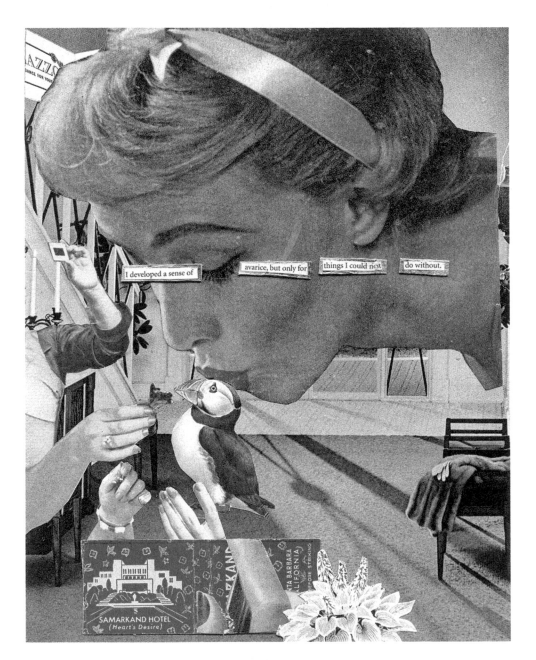

HEART'S DESIRE

Collage on paper

ARTHUR DANTO WITH WISE PUFFY CHEESE DOODLES, ROLE GAME

Digital studio photograph, 166 x 250 inches

DAVID LAWTON

NEW YORK, NEW YORK

GO, PIZZA RAT, GO!

Hey, Pizza Rat!
Save us
With your enigmatic
Pizza dragging ability

Don't let your internet celebrity
Go to your little grey rodent head
There're people who don't have enough to eat
Unlike your buddies with all that
Wasted food on every city block

Use that determination
That slid that slice down the subway stairs
To haul many to "the wrong side of the tracks"

Up the Appalachian Trail
By the slums of Mumbai
Through every desperate refugee camp

Everybody knows there is hunger
But feel helpless in the enormity of want
While everyone is grossed out by the sight of a rat
So there's nothing that can stop you

Deliver us from our guilt trip
Justify your Youtube stardom
Let that cheesy grease propel you
Go, Pizza Rat, GO!

EMILY LINSTROM

ASTORIA, OREGON

FULL CIRCLE

Photograph

"Dada was not a school of artists, but an alarm signal against declining values, routine and speculations, a desperate appeal, on behalf of all forms of art."
—Hugo Ball

EDWARD KULEMIN

SMOLENSK, RUSSIA

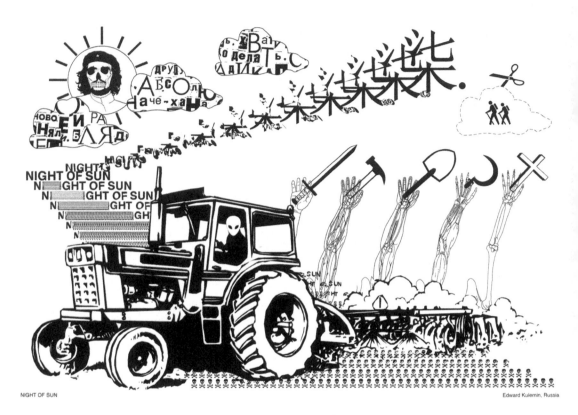

NIGHT OF SUN

Edward Kulemin, Russia

NIGHT OF SUN

Collage, digital art, 30 x 20 inches

"Light is meaningful only in
presupposes error. It is these
our life, which make it pungent,
in terms of this conflict, in the

PERE SOUSA

BRCELONA, SPAIN

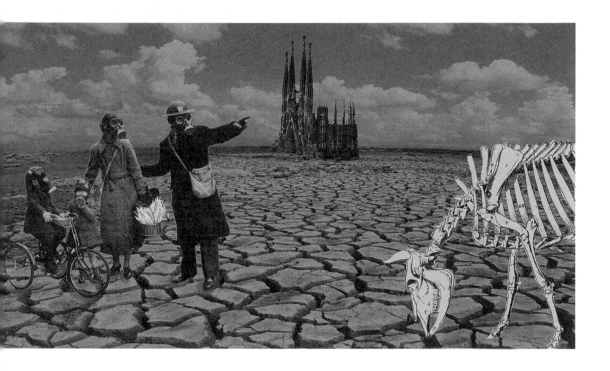

WHEAT

Collage, 5 x 2,8 inches

relation to darkness, and truth
mingled opposites which people
intoxicating. We only exist
zone where black and white clash."
—Louis Aragon

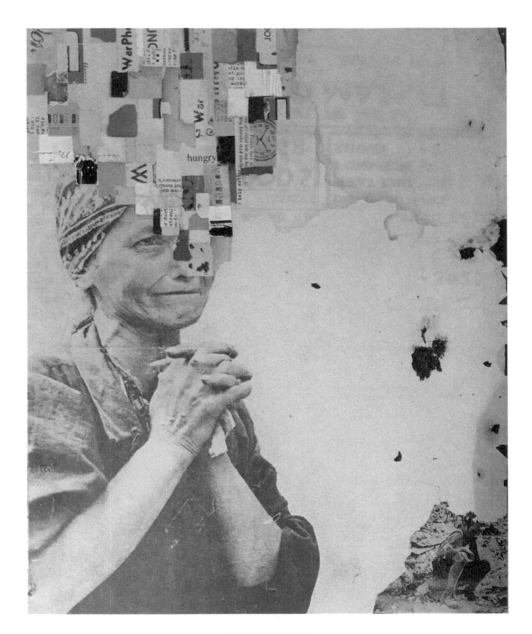

NO CIVILIANS

Cut and paste collage

SERGEY BIRYUKOV

HALLE, GERMANY

TSAR'S DEDICATION

ta- r — ra
op----------------aaaaa
Tristan Ttsara

pra---------shock

at----la----la

macromini

kro and ini
where nonsense tone
breton

Pere
 cheniye
no
pere
 sections
and glow

Paris
without skis
and you
and you
die kunst ist tot
DA-DA
where
to Zanzibar!

hura - hura!
to read a ttsara:
a ee ea ee ea ee, ea ee,
eaee, a ee
ea ee ee, ea ee
ea, ee ee, ea ee ee

here
here
then
and off
then here so
Tristan Ttsara entered

it springed on a chair
it was shaken
in clouds
as in a hammock
mister antipirin
(fire-retarding agent!)
it in night
I ran across
through machines

zh-zh-zh-zh-zh-zhu

I krasotat!

ALEXANDRE NODOPAKA

LAKE FOREST, CALIFORNIA

A MASTER DADA PLOY TO PLOT THE DADA PLOT OF DADA PLOTS

St. Dada Petersburg is loaded with Dada Egyptian artifacts.
It's a Dada love affair that dates back to the early Dada
Cairo nearly two centuries ago.

The Dada sphinxes are located on the shoreline of the
Dada River Neva next to the Dada Academy of the Fine
Arts bordering on Dada Universiteskaya Nabereshnaya.

It's been a Dada love affair between these two Dada
countries not unlike between Dada Peter and Dada
Catherine the Great and Dada Tutankhamon though
several Dada millennia apart.

I pop my Dada ears and tuck in my Dada seat on a Dada
Metrojet Flight 9268 flying back home to St. Dada
Petersburg over the Sinai Dada Peninsula. I turn on my
Dada Google eyeglasses and hear a faint Dada chatter with
a familiar Dada accent,

Dada American voice #1:
OK! I hear the job is done. The sleeper Dada Islamist
mechanic was able to get through.

Dada American voice #2:
Vlad Dada Putin will soon be on the spot.
That'll teach him to spoil our chosen playground!

Dada Arab voice:
Yes, thank you very, very much,
Dada Allah is Great and in the name of Dada Mohammed,
May He Rest in Dada, He thanks you also.

Dada American voice #1:
Don't mention it Dada.

Dada American voice #2:
Hey, Dada! Job well done.
The Russians Dadas better believe Dada ISIS did it and that
shall make them consider stop bombing our Dada terrorists.

Dada American voice #1:
Well, the name of the Dada game, is to confuse who does
what Dada to Dada whom. Besides, what's 224 Dada deaths
compared to making extra trillions of dollars in the military
industrial Dada complex selling arms to all Dada sides for
the next twenty Dada years and help with the butchery,
Inshallah Dada!

Deafening Dada Dada Dada BOOM!

VOLODYMYR BILYK
ZHYTOMYR, UKRAINE

HER SELF EATS HER LASHES (READS AS "VIYI YIYI YIST YESTVO")

Digital

JON ANDONI GOIKOETXEA URIARTE

BARAKALDO, ESPAÑA

TAMELÍ

Ánga
angoláda
psss...

Bbb...
bebíba bó.
Bó bó bó
bebíba.

Ulpi taránbo,
cónsto cónsto
cónsto
tamelí.

Tamelí
ppp...
ppp...
ppp...
tamelí.

Luspíla
lll...
lll...
lll...
luspíla.

Kála kála
kála
kalón kalí.

! Guau
tamelisí !

! Guau !

GOIKO-TAMELÍ

Máquina portátil de escribir hispano olivetti

GEDLEY BELCHIOR BRAGA

DIVINÓPOLIS, BRAZIL

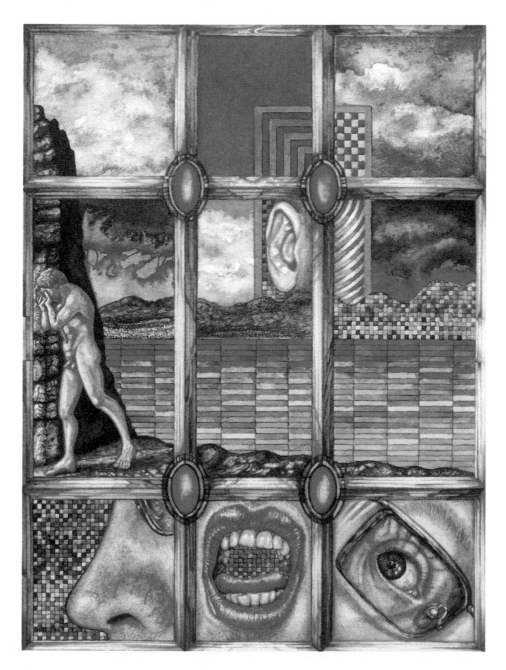

STUDY FOR SEMIOTIC SELFIE WITH PARADISE EXPULSION (AFTER MASACCIO)

Watercolor on fabriano paper; 28,5 x 21 cm

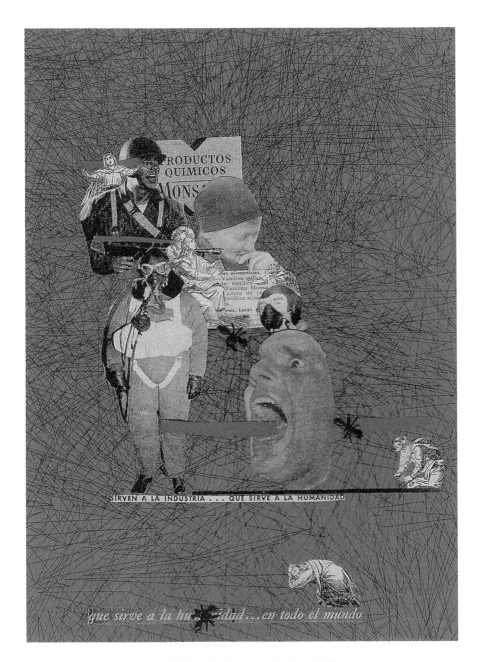

ALWAYS SERVING HUMANITY

Collage + mixed media, 3.29 x 4.68 inches

OBJET QUOTIDIEN

Collage a4 (32 x 23 cm)

MARC JAMES LÉGER

MONTREAL, CANADA

HOARDING, MOUNT-ROYAL AVENUE

Photograph

Poster hoarding announcing the annual ATSA (Action Terroriste Socialement Acceptable) event on Place Émilie-Gamelin. Since 1998 the Montreal collective has occupied a public plaza in downtown Montreal during the cold month of November to bring public attention to the crisis of homelessness. These posters are an anomaly amidst the usual banal offerings to the creative class. The posters were designed for ATSA by Compagnie et cie and Shoot Studio. Photo by Marc James Léger.

ALFONSO IANDIORIO & LOIS KAGAN MINGUS

NEW YORK, NEW YORK

HUNGRY HEAT GRABS GLOBE

Photo collage, Alfonso Iandiorio (above); Text, Lois Kagan Mingus (below)

Magnification of the human spirit verses universal ills.

The piano played itself these years, the blurry composition is
abuse, destruction, poverty.
Not at all smooth, no melody.

War is raw backwards and sewing sewage water doesn't work.

Can we cool our way out.
Can we eat our way out.
Can we buy our way out.
Can we negotiate.
Can we stop justifying.
Can we stop rationalizing
racism, bigotry, borders, religion, killing.

Can we repair revenge.
Can we disarm.
Can we hope from the future backwards.
Just one stream of time going both ways simultaneously.

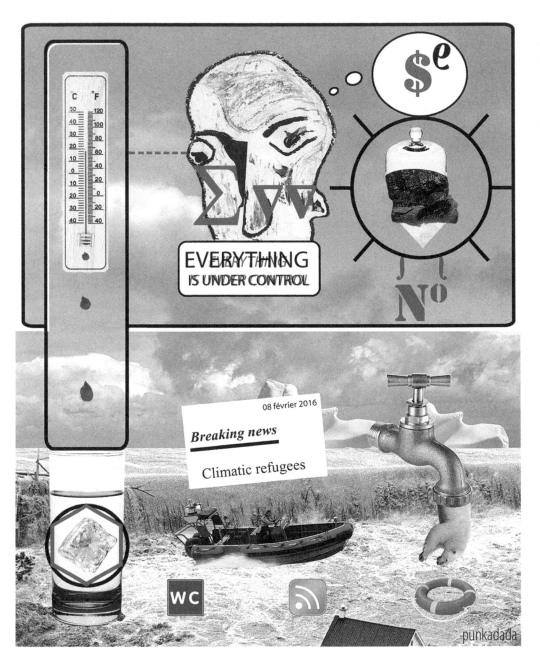

WORLD CONCERNS 3 : GLOBAL WARMING

Digital collage and infographic; 8 x 10 inches

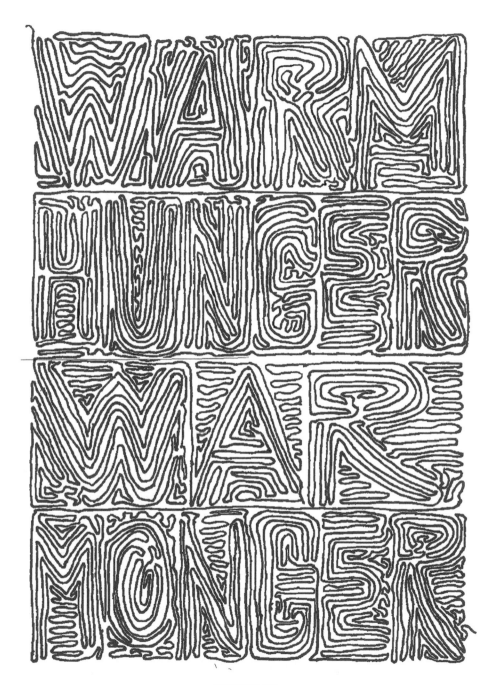

UNTITLED

Ink on paper

Recent and Forthcoming Books from Three Rooms Press

FICTION

Meagan Brothers
Weird Girl and What's His Name

Ron Dakron
Hello Devilfish!

Michael T. Fournier
Hidden Wheel
Swing State

Janet Hamill
Tales from the Eternal Café
(Introduction by Patti Smith)

Eamon Loingsigh
Light of the Diddicoy
Exile on Bridge Street

Aram Saroyan
Still Night in L.A.

Richard Vetere
The Writers Afterlife
Champagne and Cocaine

MEMOIR & BIOGRAPHY

Nassrine Azimi and
Michel Wasserman
Last Boat to Yokohama:
The Life and Legacy of
Beate Sirota Gordon

James Carr
BAD: The Autobiography of
James Carr

Richard Katrovas
Raising Girls in Bohemia:
Meditations of an American Father;
A Memoir in Essays

Judith Malina
Full Moon Stages: Personal Notes
from 50 Years of The Living Theatre

Stephen Spotte
My Watery Self:
Memoirs of a Marine Scientist

HUMOR

Peter Carlaftes
A Year on Facebook

PHOTOGRAPHY-MEMOIR

Mike Watt
On & Off Bass

SHORT STORY ANTHOLOGY

Dark City Lights: New York Stories
edited by Lawrence Block

Have a NYC I, II & III:
New York Short Stories;
edited by Peter Carlaftes
& Kat Georges

Crime + Music: The Sounds of Noir
edited by Jim Fusilli

Songs of My Selfie:
An Anthology of Millennial Stories
edited by Constance Renfrow

This Way to the End Times:
Classic and New Stories of
the Apocalypse
edited by Robert Silverberg

MIXED MEDIA

John S. Paul
Sign Language: A Painter's
Notebook (photography, poetry
and prose)

TRANSLATIONS

Thomas Bernhard
On Earth and in Hell
(poems of Thomas Bernhard
with English translations by
Peter Waugh)

Patrizia Gattaceca
Isula d'Anima / Soul Island
(poems by the author
in Corsican with English
translations)

César Vallejo | Gerard Malanga
Malanga Chasing Vallejo
(selected poems of César Vallejo
with English translations
and additional notes by
Gerard Malanga)

George Wallace
EOS: Abductor of Men
(selected poems of George
Wallace with Greek translations)

DADA

Maintenant: A Journal of
Contemporary Dada Writing & Art
(Annual, since 2008)

FILM & PLAYS

Israel Horovitz
My Old Lady: Complete Stage Play
and Screenplay with an Essay on
Adaptation

Peter Carlaftes
Triumph For Rent (3 Plays)
Teatrophy (3 More Plays)

POETRY COLLECTIONS

Hala Alyan
Atrium

Peter Carlaftes
DrunkYard Dog
I Fold with the Hand I Was Dealt

Thomas Fucaloro
It Starts from the Belly and Blooms
Inheriting Craziness is Like
a Soft Halo of Light

Kat Georges
Our Lady of the Hunger

Robert Gibbons
Close to the Tree

Israel Horovitz
Heaven and Other Poems

David Lawton
Sharp Blue Stream

Jane LeCroy
Signature Play

Philip Meersman
This is Belgian Chocolate

Jane Ormerod
Recreational Vehicles on Fire
Welcome to the Museum of Cattle

Lisa Panepinto
On This Borrowed Bike

George Wallace
Poppin' Johnny

THREE ROOMS PRESS

Three Rooms Press | New York, NY | Current Catalog: www.threeroomspress.com
Three Rooms Press books are distributed by PGW/Perseus: www.pgw.com

CPSIA information can be obtained
at www.ICGtesting.com
Printed in the USA
LVOW06s1152220716
497371LV00009B/16/P